3 0250 09257 5708

D1106539

DIC
2000

DATE DUE

BOOKS MAY BE RECALLED

AFTER 10 DAYS

Printed
in USA

A Sense of Place

IRISH LIVES · IRISH LANDSCAPES

A Sense of Place

IRISH LIVES • IRISH LANDSCAPES

ROSLYN DEE & GERRY SANDFORD

NEW
ISLAND

First published October 2000 by
New Island,
2 Brookside,
Dundrum Road,
Dublin 14
Ireland

Text: Copyright © 2000 Roslyn Dee
Photographs: Copyright © 2000 Gerry Sandford

All rights reserved. No part of this book may be
reproduced or utilised in any form or by any
means electronic or mechanical, including
photography, photocopying, filming, recording,
video recording, or by any information storage
and retrieval system, or shall not, by way of trade
or otherwise, be lent, resold or otherwise
circulated in any form of binding or cover other
than that in which it is published without prior
permission in writing from the publisher.

The moral rights of the author and the
photographer have been asserted.

**The publisher gratefully acknowledges the
generous support of EBS Building Society
towards the publication
of this volume.**

An equivalent CIP catalogue record for this book
is available from the British Library

ISBN 1 902602 30 7

New Island Books receives financial assistance
from The Arts Council (An Chomhairle Ealaíon),
Dublin, Ireland.

Book and cover design: De Facto Ltd
Set in Interstate Light 8.5/11.5pt
Photographic processing: Film Bank, Dublin
Photographic scanning: Colour Repro, Dublin
Printed in Dublin by Betaprint

Preceding photographs:
Dun Laoghaire Pier, Co Dublin
Gleann an Atha, Co Donegal

For Gerry's son, Demian
and
Roslyn's son, Nicholas

Contents

Introduction

Growing up in Coleraine in Co Derry, every Thursday brought, through the letter-box, a copy of the local newspaper, *The Coleraine Chronicle*. My mother and father would always divide it up and read it together, passing bits to each other when they had finished. The most eagerly awaited page every week in our house was a lengthy column by local writer, W 'Speedy' Moore. Something of a local 'character' himself (he published his first novel in 1997 at the age of 85), Speedy's column was entitled 'People & Places' and dealt with just that - stories of people's lives in the context of different locations. All those years ago it left its mark on me.

People and places, lives and landscapes - the relationship is an interesting one since places mean different things to different people. What for someone is the most idyllic, away-from-it-all spot is, for someone else, a nightmare of isolation. For some people a particular location has happy memories while for others it has associations of sadness, even despair. Sometimes a place has importance because of childhood connections, or because something significant happened there, something that changed, or shaped in some way, the direction of a person's life.

So we decided, photographer Gerry Sandford and myself, to find out what places in Ireland were important to people and why they had such resonances in their lives. This book has been, for both of us, a journey in itself - both a physical journey, travelling all over Ireland to interview and photograph, and an emotional journey in which we felt privileged to meet so many people who were prepared to give so much of themselves in the telling of their stories.

This is not a book about 'favourite' places. It is more a book about places that have a special relevance in people's lives. Sometimes it is a place from the past, a spot rarely visited anymore but which nonetheless retains a great significance; at other times it is a place which is central to the person's being, the place, in effect, that defines them. Childhood raises its head time and again but not always in a sentimental way. And then there is the sea. There is simply no getting away from it. If ever we doubted our 'island nation' status, it is undeniably confirmed here, by the lure of the sea for so many interviewees in this anthology.

Sometimes things didn't quite work out - two stories don't appear here because it proved impossible, in the end, for the people in question to travel long distances to be photographed *in situ*; the late great motorcycling legend Joey Dunlop was tragically killed just as a letter was ready to wing its way to Ballymoney to ask him to participate. Occasionally the scheduling was crazy - driving two-hundred miles and then back home again the same day only to discover that a location nearby was going to have to be accommodated a few days later, not weeks after, as originally planned. Another four-hundred-mile round-trip.

Overall though it has been a wonderful project, giving Gerry and myself a real sense of the diversity of this island on which we all live. From wild wetlands to concrete cityscapes, from the vast Atlantic to a tiny holy well, all with different meanings, different memories.

And in the end it was the connection that was the vital element: that point of contact between person and place - the 'why here?' factor - that precise encapsulation of why one particular location conveys such a personal sense of place. Why it touches, as WB Yeats wrote of *his* place, Innisfree, 'the deep heart's core'.

Roslyn Dee
September 2000

Liz McManus

Martello Terrace and Seafront, Bray, Co Wicklow

Liz McManus in the window of Number 1, Martello Terrace, with views of the prom (far right); the aptly named hotel at the other end of the seafront (above)

Picture this. A small boy, five or six years of age, in a house by the sea. A well-behaved, slim little boy, frightened both of the sea and of dogs, a boy with a pale face and eyes of the palest blue, eyes that were problematic and would soon force him into wearing glasses. A happy child, dubbed 'Sunny Jim' by his family, who loved to put on plays and to sing. Indeed, at the age of only six he sang in a concert at the local boat club. A boy with a life-long fear of thunderstorms, which he learned from his governess in the years that she lived with him in this house by the sea. A boy who would become famous and end his days far from this childhood home at Number 1, Martello Terrace, Bray. Yet nowadays, on the seafront in Bray, there's no escaping the James Joyce factor; the presence of the artist as a young boy lingers on. And if, like Liz McManus and her family, you live in the house where he lived and played during his early childhood, he is an even more permanent, yet invisible presence.

It is not something with which Liz McManus has any problem. It is actually an added dimension to her life here, beside the sea, in the house at the end of the once-majestic seafront in Bray.

'When my own three boys were small,' she says, 'I always had a feeling that there was a fourth boy around ... James Joyce's first love was a little girl who lived at Number 4 on the terrace - those patterns repeat themselves, children playing, in and out of houses, all of that continues.'

You can't get much closer to the sea than Liz McManus's house. 'It used to be scary at times,' she says. 'The seafront is better protected now but some years ago, when you had a south-east gale and a high tide, the whole terrace could be marooned. You'd end up with vast deposits of seaweed and fish on your balcony!'

She loves it here, especially the view from her home, a vista which runs the length of the seafront - 'the magnet of the prom' as she calls it.

'It's a very rare time that you don't see someone out walking the prom. It just keeps drawing you back. To have that feeling in the morning of endless possibilities ... with the sun rising over the sea and the very natural hinterland of the mountains behind it. By living here I'm able to nourish a deep need to have contact with natural forces which are, after all, eternal. It balances well alongside this fast-moving, short-term life.'

Her home anchors her. Before living here, she says, she never really had a strong sense of place in her life. 'People ask me where I come from and I can never answer that question satisfactorily. My early life was peripatetic. I was born in Canada and lived in France, Switzerland ... all over the place. My father came from Cork, my mother from Northern Ireland.'

Liz McManus has lived in Martello Terrace for eighteen years now. 'Before that I had no clear route but when we moved here I had a definite sense of "this is it now". I hope to be carried out in a box.'

There's no getting away from the dramatic setting. The terrace is tucked in at the end of a tremendous stretch of promenade, flanked by Bray Head at the other end, and almost every window in the house itself affords a sea view.

'I also love the idea,' she explains, 'of living on the interface between urban life - and believe me, I'm a very urban person - and natural forces. It is vital to always have a connection to some other form of consciousness.'

Bray's role as a gateway to Wicklow means 'having a foot in each dimension. I suppose it's something to do with a desire not to be trapped or boxed in,' she says. It's certainly something that reflects her own general openness, her lack of rigidity. From her home she can walk the prom and climb the head to take the cliff walk round to Greystones. 'Suddenly you're into quite wild landscape. It's not unlike the West of Ireland.' Again it's the contrast that so appeals; stepping from townscape to countryside within a few minutes.

And townscape it most definitely is. 'Bray is a town with its own identity,' explains its Labour TD. 'It's not just a suburb of Dublin - there's a real infrastructure here. The town really only took off with the arrival of the railway line in the mid-nineteenth century. Then it mushroomed, becoming a rather upmarket resort for a time - the Brighton of Ireland. Oscar Wilde's father had property here and when James Joyce's father moved the family here [in 1887] it was really rather grand. There's still a faded Victorian grandeur about it and I like that combination ... Let's not forget though that there were lots of things about Victorian life that were far from grand.'

These days, she admits that the Co Wicklow town doesn't have the best reputation in the world, but says that people who move here are surprised by what Bray has to offer. Her first memories of it are as a child when, she says, 'it had a slight whiff of danger about it - the dodgems, the amusements, all that sort of thing'.

With 'all that sort of thing' still part and parcel of the town's landscape, Liz McManus lives within walking distance of the candy floss stalls and the once-dangerous dodgems. And there's a cultural side to the town also, including her own house, which is a James Joyce heritage site, open to the public on certain days of the year. 'It's an aspect of our home that we can't ignore,' she says. And no, it isn't haunted, although there was one time when she thought it may have been. 'When the Joyces lived here it was a very musical house. James Joyce's father used to invite friends out from Dublin for musical evenings. One night, a few years ago, I woke up to an unfamiliar tinkling sound. Unfortunately it turned out that there was a quite logical explanation: the owner of the house next door, a composer, had returned in the middle of the night, having been away for a while, and started to play the piano!'

Back out on the seafront, once again it's the mix that continues to intrigue Liz McManus. 'There are great characters in Bray, an extraordinary range of people. The seafront itself is very democratic. Everyone uses it - old and young, rich and poor, locals and tourists.'

What would she miss most if she ever had to leave?

'The presence of the sea, I'd find that very hard to leave. The constancy of it is addictive.'

Liz McManus is a politician and writer. She worked as an architect, writer and journalist until 1992, when she was elected Democratic Left TD for Wicklow. She has been Minister of State for Housing and Urban Renewal and is now Labour Party spokesperson on Health. Among her literary prizes is the Irish PEN Award for her short stories, won in 1989.

Eamonn McCann

Eamonn McCann in front of 'the single most important sentence I ever wrote' (far right); view of Derry city (above)

Eamonn McCann is a journalist, writer and political campaigner. Expelled from Queen's University Belfast in 1965 for political activities, he was one of the chief organisers of the Northern Ireland Civil Rights Movement in the Sixties. He has worked as a journalist for a number of publications including *The Sunday Tribune* newspaper and *Hot Press* magazine. Among his published books are *War and an Irish Town* (1974) and *Bloody Sunday in Derry: What Really Happened* (1992). He lives in Derry's Bogside.

Free Derry Wall, Derry

It stands alone, on a traffic island in Derry. Green manicured grass all around. Stark black lettering jumps off the pristine white-painted backdrop. It's almost surreal: the gable of a house, of a *real* house, a house where a family once lived, no longer attached to anything – not to a street, not to another house, not even to the rest of itself. The past is gone, seems to be the message, knocked down, wiped away, and yet here, on a sunny summer's morning in the Bogside, the past is still evocatively captured in this iconic image of a white wall and just six black words: YOU ARE NOW ENTERING FREE DERRY.

'It's the single most important sentence I ever wrote,' says Eamonn McCann. For this man of many sentences, that's quite a statement. Yet you believe him, the man who, on that night of discontent way back in January 1969, came up with the words, the slogan – call it what you will – that epitomised a people ready for resistance.

Free Derry Wall (formerly known as Free Derry Corner in the days when it was still part of a real house on a street) and the message it conveys will always be the legacy of Eamonn McCann. It's important to him, he says, for two reasons. The first of those is that, much as he dislikes its status as a 'monument', it has become a symbol for protest. Meetings are still held there, demonstrators for various causes use the other side of the wall as their noticeboard, so that there is still a living, breathing dimension to it. But make no mistake about it, this is an icon. 'There are even tea towels, T-shirts and the like,' says Eamonn McCann, somewhat amused at this rather bizarre turn of events.

The second reason that he cites for its importance in his life is, of course, his authorship of the actual words. He readily admits that he did not quite pluck them out of the air on the night in question. It was New Year's night, 1969, the day of the People's Democracy civil rights march from Belfast to Derry, a march which ended in violence and injury when the marchers were ambushed by loyalists at Burntollet Bridge just outside Derry. Eamonn McCann had been following the student protests across the globe over the previous months. One particular image stuck in his head. In California, radical students had taken over buildings in Berkeley University. Eamonn McCann remembered a television image of the slogan, 'You Are Now Entering Free Berkeley', which featured in their protests. And thus 'Free Derry' was born.

'It was based on Berkeley,' he says. 'Now, with the connotations of 'Free Ireland' its significance seems different. But actually, it wasn't about looking back, it was about looking forward, looking out towards the rest of the world.'

It was a catch-phrase for a cause, a slogan that captured a particular moment at the very start of what was to become 'The Troubles'. 'The very minute it went up,' says Eamonn, 'it caught on.'

Yet for years he could not remember who had actually painted the words on the wall for him that night in the Bogside. Then in 1974, when he was writing his book *War and an Irish Town,* he went in search of that person. John 'Caker' Casey's name kept coming up, and when asked by Eamonn, Caker said, yes, he could remember painting that night. And so, he was written into history as the man who painted YOU ARE NOW ENTERING FREE DERRY.

'For years,' says Eamonn McCann, 'Caker enjoyed a certain status in relation to the wall. He was presented with a plaque to commemorate his involvement. His name even appears on those tea towels.'

Then, about five years ago, Eamonn was accosted by a man in a bar. 'Hey,' he said, 'I've a bone to pick with you McCann. It wasn't Caker who painted the wall that night, it was me.' Still Eamonn had no recollection. Until the man told him something that jogged his memory: 'Don't you remember Eamonn, I was painting the words and I came over and said to you "Is it one R or two Rs in entering?"'

It was that little detail that brought the memory of it flooding back for Eamonn. Here was Liam, the man who really painted the wall. Caker might have his plaques and his name on tea towels and the like, but he never actually painted the slogan. 'It's like the film *Who Shot Liberty Valance?,*' laughs Eamonn McCann. 'Print the legend!'

He talks about the changing nature of the wall, which he lived within sight of back then. He now lives only a couple of hundred yards away. 'It was the first of its type,' he says. 'You have to remember that within weeks of the slogan going up, it became Free Derry Corner. It was connected with a state of mind, it really wasn't a physical thing, a physical place.'

It is flanked, in the Bogside, across the road from its now glorious isolation, by impressive murals on still-inhabited houses. Bernadette Devlin is there and so are other images depicting various civil-rights issues. Eamonn McCann makes the point that all of the murals in this part of his city emanate from civil rights issues, not from the armed struggle. And the wall, of course, because of its own iconic status, is now depicted in other murals – a mural within a mural. There's one particularly savage UVF mural, in the Waterside in Derry, in which the wall is used like a tombstone with the figure of Death, complete with Union Jack, running amok above it.

There were times, of course, when the wall looked different to how it looks now. Various attempts were made to deface it, for example, and it was often paint-bombed by British soldiers. Inevitably, though, it was cleaned up, an act which Eamonn McCann is unsure was always the right course of action. You get the impression that he would prefer to see the wall wearing all of its symbols from the past, so that in its perfection and imperfection it remains a *real* symbol and testament to what has gone before. 'A living reality' are the words of Diego Rivera chosen by Eamonn McCann to convey this.

Eight or nine years ago it also took on a different look, when artist Colin Darke painted it in red and yellow. Again the legend machine sprang into action and, before long, it had been interpreted

The UVF mural in the Waterside depicting Free Derry Wall as a tombstone (far right); looking across the Foyle (above)

as a particular political statement. 'Everyone had had Viet Cong flags or posters on their bedroom walls at some stage or other,' explains Eamonn. 'So it was assumed that the artist had painted the wall in keeping with the Viet Cong colours.' Wrong again. 'It materialised,' he says with much amusement, 'that Colin Darke had had the paint donated free and it just happened to be a batch of red and a batch of yellow.' Such is the nature of the wall that it lends itself easily to legend.

Over the years the mural was touched up, gradually becoming neater and neater. Now it is at the centre of the traffic island, railed off, with its well-cut grass and 'detached,' as Eamonn McCann describes it, 'from day-to-day life. It is now a monument, virtually a new wall ... there's talk of floodlights. It's formalised, detached and removed from reality.' He tells you that the original house belonged to Johnny Kane and his family. Johnny still lives in the area, just a couple of hundred yards away from his now iconic gable wall. 'Johnny is now a quiz question,' laughs Eamonn McCann. 'Whose house was used for the painting of YOU ARE NOW ENTERING FREE DERRY in 1969? - that kind of thing.'

While Eamonn McCann may feel that the wall is now too much

of a monument, too removed from reality, its symbolic status is unchanged. It still manages to evoke strong memories, remaining a living thing in the mind's eye, a where-were-you-when-such-and-such-happened kind of place. Inevitably for Eamonn McCann, one of his most vivid memories is of Bloody Sunday. 'Bernadette [Devlin] was speaking at the wall when the shooting started. Minutes later I was lying on the side of the road ...'

When the Birmingham Six were released there was a rally at the wall, and all sorts of important Republican events have been marked there through the years. It continues to function as a rallying spot, the place from which marches begin. Despite its now 'monumental' status it looks like a pattern set to continue.

YOU ARE NOW ENTERING FREE DERRY. That's what it states. But in truth, this is not the case. For Johnny Kane's house wasn't on the edge of the Bogside, it was well into it. And therein lies the irony, perhaps. Those who hadn't fully grasped the realities of the situation back in the early Seventies thought that they were entering 'Free' Derry. In fact, they were already there. Free Derry was actually all around them. For Free Derry was, like Eamonn McCann's wall, a real place *and* a state of mind.

Alice Maher

St Pecaun's Well, Kilmoyler, Co Tipperary

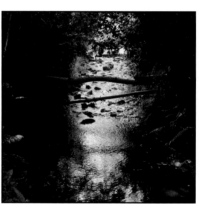

Alice Maher at St Pecaun's: 'more drawn to the overhanging places' (far right); beside the stream (right); the hand-written signpost pointing the way (above)

Alice Maher was born in Cahir, Co Tipperary and studied at the NIHE in Limerick, at the Crawford College of Art in Cork and the University of Ulster, Belfast. She was awarded a Fulbright scholarship to San Francisco Art Institute in 1986. She has exhibited widely at home and abroad with a solo exhibition running in New York in autumn 2000. She is a member of Aosdána and lives in Dublin.

There is a line, just a couple of words actually, in the American poet Samuel Menashe's poem 'Ruin', in which he refers to 'pristine thorns'. The combination of those two words jumps out at you when first you read them. How on earth can thorns be 'pristine'? Yet they can - take a look at Alice Maher's 'House of Thorns', a miniature piece made in 1995 for her Compulsive Objects exhibition. Literally a small house made of thorns - beautiful, perfect, pristine.

Alice Maher likes small things. Her work is also informed by all things rural, so that there are always echoes of her past, of the things that she touched and plucked and played among in her childhood setting of south Tipperary. So it comes as no surprise to discover that St Pecaun's Well holds such significance for her - it is on home territory, it is bound up with myth and memory (both themes which run through her work), and it's a small place, not some sweeping vista or a dramatic thundering sea.

'Yes,' she says, 'this is a very small place but when I was a child it was a big place. I'm very interested in scale and both experiences of this well are equally real to me.' It is a quietly beautiful spot, hidden away beside a babbling brook, with only carefully hand-written signposts pointing the way. To get there, you make your way from a little country road across a railway line, through a working farmyard. Then, following the markers, you walk alongside a stream until, on your left, you come upon a dark, overgrown place, with a huge chestnut tree cascading its branches towards the ground. Step over the stile and there is the well, in all its dark and secretive splendour.

Right beside this spot is a large field, laid out on a hill, and it was to here that Alice Maher used to come, as a child, on the annual sports pilgrimage on the first Friday in August.

'This place means summer for me,' Alice explains. 'We'd walk here for the sports and the religious 'pattern', which was held in the nearby church ruins, just over the stream from the well. That was a kind of Stations of the Cross and there was an annual Mass. The sports were great fun. The hillside here was like a natural amphitheatre and all the local people attended. A shop was set up under a tree, selling lemonade and the like, and it was a great place for the boys to meet the girls while the mothers chatted to friends and the fathers all hung out together around the cars. It still goes on, which is marvellous.'

Even though she draws on the past here there's absolutely no nostalgia attached to Alice's reminiscences. 'I don't suffer from that,' she says. 'Nostalgia is something that I regard as an illness - that's what makes people buy houses in the country!'

St Pecaun's Well is still used by the locals. A blue and white cup, which is truly pristine - no chipped edges, handle still intact - sits beside the water, for those who wish to bend down and take the customary three sips: Father, Son and Holy Ghost, one presumes.

Alice herself isn't sure of those origins. Fact and exactitude don't interest her as she is far more concerned with the blurring of things. 'I haven't a clue who St Pecaun was,' she says. 'Most people round here haven't a notion either - this is simply a way of connecting with the past without the necessity of all the facts. A lot of my work deals with the subject of memory and how it changes with storytelling and with myth. Christian wells like this one just took over from what was here before - it's all about overlay, layers of memory and that, in a way, is how we all remember our childhoods.'

She bends and drinks from the well. Then, rising, she explains that water informs her work - 'birth through water, its healing powers, transformations ... if a place is important it retains that importance.' She refers to one of her works, 'Les Filles d'Ouranos', installations that she undertook in France in the mid- to late-Nineties which were, in effect, heads floating in water. There's another work, 'Swimmers', which also draws on the power of water, depicting floating tresses, mermaid-like, cast in bronze. 'I'd always play as a child here, along the ditches, with the green weeds in the water. I used to imagine that the weeds were mermaids, trapped like salmon. I think that unless you actually block out those memories they are bound to surface in some way later in your life.'

Alice Maher's attachment to St Pecaun's may well operate through myth and memory but there is also a personal relevance. 'When my mother was dying from a very long illness, she was often very thirsty,' she recalls, 'and she used to ask for water from the well. It wasn't that she thought it would cure her or anything like that, she just wanted us to fetch it for her from here - that was her way of drinking from her own memory, a final ritual for her. People perform rituals throughout their lives and for us, her family, to get the water for her, was a ritual as well.'

Back in the gloom of the well Alice reiterates why this source draws her back time and again: 'For a lot of people the attraction to a particular spot is because of its wide open vista. I'm far more drawn to the overhanging places, to the shadows ... I feel at home in the rushes and the reeds, not in the clear spaces. Most people see out; when they look at a view, at a vastness of some kind, they are looking out. They are not in it.'

You can tell that she is truly in touch here, a part of things in this place where past and present merge. She uses bees, thorns, nettles, in her work. Elemental items. 'An actual thorn or a nettle says everything to me about a hedge,' she says, 'while a picture of it is just a picture. My work is shaped by here, by this well, by this setting. I'm not looking out at it. It's important for me not to be outside it, not to be an observer trying to control the landscape, control nature. I carry it around with me always - in my head and in my heart.'

Paul Durcan

Paul Durcan in the 'One True Gloom' of University Church (far right); into the Green from the Grafton Street entrance (above)

St Stephen's Green, Dublin

Paul Durcan is a Dublin-born poet who studied archaeology and medieval history at University College Cork. His first book of poems, *Endsville* (with Brian Lynch), was published in 1967 and has been followed by sixteen others. He won the Patrick Kavanagh Poetry Award in 1974 and the Whitbread Poetry Award, for *Daddy, Daddy,* in 1990. He travels extensively, giving poetry readings all over the world. His most recent work, *Greetings to Our Friends in Brazil,* a collection of one hundred poems, was published in 1999.

'It's a kind of bridge on the Ramblas, a Nevskiy Prospekt, a place that was once *the* heart at the heart of a great European Latin Quarter. It's also the real River Boyne.'

Paul Durcan reflects on St Stephen's Green, a place that for him is not simply a grassy expanse with a pond. 'It's not to me a park, it is rather the place where Leeson Street and Grafton Street join up - a great thoroughfare. You don't think, I'm taking a shortcut, the Green is part of the main thoroughfare.'

And the real River Boyne?

'It was an amazing place in the Sixties, the excitement, the atmosphere was really something else. There, on its southern side was UCD, the Catholic university and on the north, the great Protestant university of Trinity College. From Hartigans, Dwyers and the Singing Kettle café on Leeson Street right across to McDaids in Harry Street there was a great mixture of writers, students, retired and budding revolutionaries - non-conformists of all kinds. Then something happened here that put a stake through my heart, through the heart of Dublin city and through the heart of Ireland - it was decided to transplant UCD out of the Green. Why? The prime reason was, and I quote Dr Tierney, the UCD President of the time, 'to remove the students from the Protestant sphere of influence'. It makes me ashamed to the roots of my being, yet it would be more destructive to forget it. I grew up in that world of subliminal fascism.'

It destroyed things forever, says Paul Durcan, and the Green, for him, with many of its once magnificent buildings now gone, became something of 'a Vale of Tears, yet always with the potential to be the Garden of Eden. If that terrible sectarianism hadn't been there, if the spirit of people like Douglas Hyde had prevailed, bit by bit UCD would have bought the buildings on the Green and the human Georgian landscape would have remained.'

Yet still he loves the place, both in the general and in the particular. Yes, it's flawed, dappled in some way, a bit hit and miss as it were but, to borrow from Gerard Manley Hopkins who lived and died on St Stephen's Green, there's a Glory-be-to-God-for-dappled-things sense about Paul Durcan's emotional response to this heart of the city in which he grew up.

'We lived on the other side of Leeson Street Bridge. On Sundays we went to mass and our parish church was University Church. Then, on the west side of the Green there was the cinema and a great toy shop, Geary's, near the top of Grafton Street. And the Shelbourne Hotel, of course; I was always very aware of the building, with its four handmaidens outside the door.'

Mention of the Shelbourne and he's off again with more stories. He recalls an account of the Easter Rising, quoting verbatim at times from the text, and describes one particular incident, the shooting dead of a man on the corner of the Green by a bunch of undisciplined volunteers. 'Just over there,' he says, pointing to the spot and creating, with a few well-chosen words, the atmosphere of yesteryear in a way that makes you believe it happened last week, last night, perhaps only hours ago.

The Green and its environs has been a running thread throughout Paul Durcan's life. As a child he was very sick and spent months in Vincent's Hospital, then located close to the junction with Leeson Street. In his late teens he became aware of the pub/literary culture that gave the area its distinctive Latin-Quarter ambience. And later, when he was 'homeless, penniless, futureless' he would sleep in Stephen's Green 'now and then, in the summer'.

Nowadays, when he stands on the corner and looks down Leeson Street, he can see, in his mind's eye, the people who populated his life at an earlier time. 'Mary Lavin lived down there, on the left ... Leland Bardwell on the right - I can see her basement, No 33 Lower Leeson Street. She was one of the first poets I ever knew. Then there was Anthony Cronin, Liam Hourican, Michael Hartnett, John Moriarity, Ruth Dudley-Edwards, Emer Philbin ... they were truly wonderful times.'

University Church has an especially potent resonance for Paul Durcan. As a boy attending mass there he had, he says, 'a child's fascination for this funny little building, wedged in between two larger structures. When you walk in,' he explains, 'it's like a procession of boxes - into the porch, then from the porch into the church itself and from there to the altar.'

The Durcan family sat in the gallery, an added appeal for a child, like climbing to the high seats in the cinema or wanting to sit upstairs on a double-decker bus. He remembers the theatricality of it, watching from the gallery and waiting for the priest to appear, each Sunday, from the same door on the right of the altar - Enter, Stage Right, so to speak. He still visits the church - 'If I'm going past it, I'd always come in, into the One True Gloom.'

A bust of Cardinal Newman rests on one of the exquisite, almost Middle-Eastern, walls inside University Church. He is a gigantic figure in Paul Durcan's personal roll of honour. 'The Green to me,' he says, 'is really three people - Newman, O'Donovan Rossa and Thomas Kettle. Newman is one of my great heroes. Did you know that James Joyce thought Newman the greatest prose writer of all time?'

Back out from the golden gloom of the church and into the damp, misty greenery of Stephen's Green itself. He knows all the landmarks well; the Fountain of the Three Graces at the Leeson Street entrance with what he calls its 'old-fashioned dignity' is a place that he has often sat, 'in good and bad times'. The park itself has many memories of love won and lost - 'I remember sitting under that tree,' he says, 'plucking blades of grass - in autumn and in early spring there's a moisture of romance.'

The arch at the Grafton Street side reminds him of the many times he passed through en route to McDaids in the days when Patrick Kavanagh held court. The structure itself is a memorial to the fallen from the Boer War. He resents the notion that it is perceived by

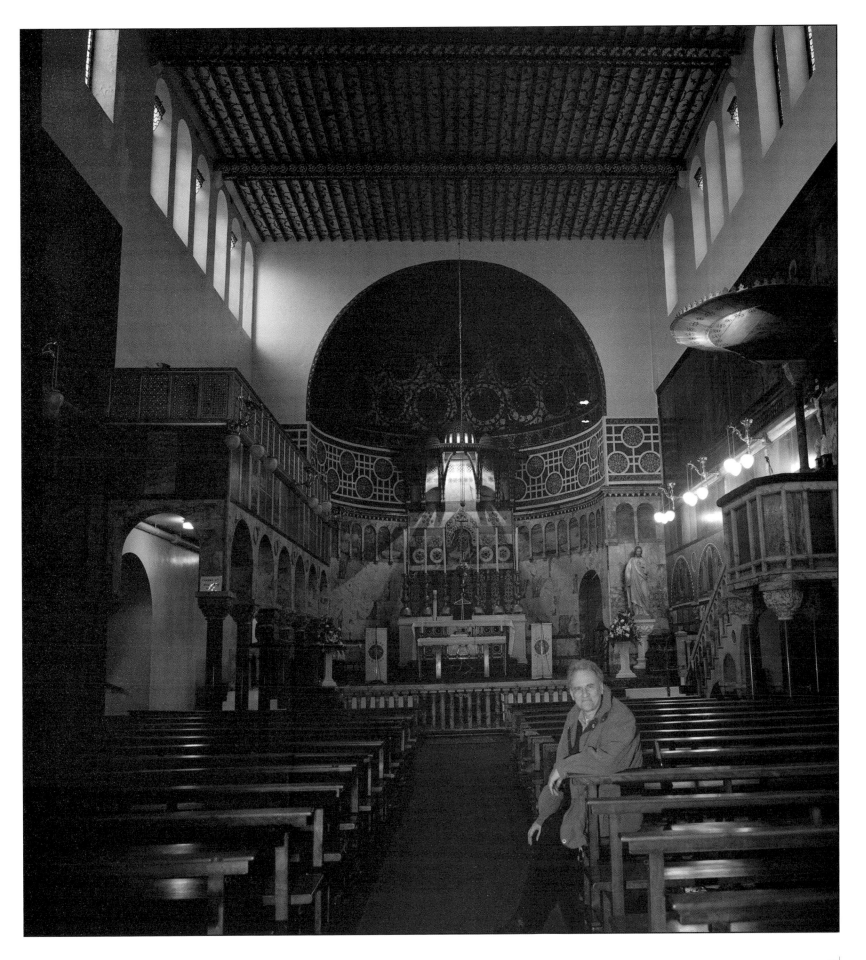

Memorial to the Boer War
dead: 'these men were real
Dubs' (far right); the Fountain
of the Three Graces with its
'old-fashioned dignity' (right)

some as a kind of traitors' gate – 'Just look at it, read the names and you'll see that these men were real Dubs. The arch is a thing of beauty ... a small Arc de Triomphe ... there's a sense of the Champs Élysée.'

And finally, one poet to another, it is to Tom Kettle that Paul Durcan turns to mark the end of this odyssey.

A monument to Kettle, a bust, in effect, erected in memory of the poet who fought and died in September 1916 at the Battle of the Somme, stands in the middle of the Green. The words inscribed on the plinth are Kettle's own, a sonnet written to his daughter Betty just a few days before he fell, mortally wounded, at Guinchy. The words encapsulate both the mood of the man and that of the time, explaining how death in the trenches was:

> ... not for flag nor king nor emperor
> But for a dream born in a herdsman's shed
> And for the secret scripture of the poor

Kettle speaks of life, of love, of loyalty and equality. And, in a strange way, those are the sentiments that best reflect Paul Durcan's own journey, down the years, around the Green in Dublin.

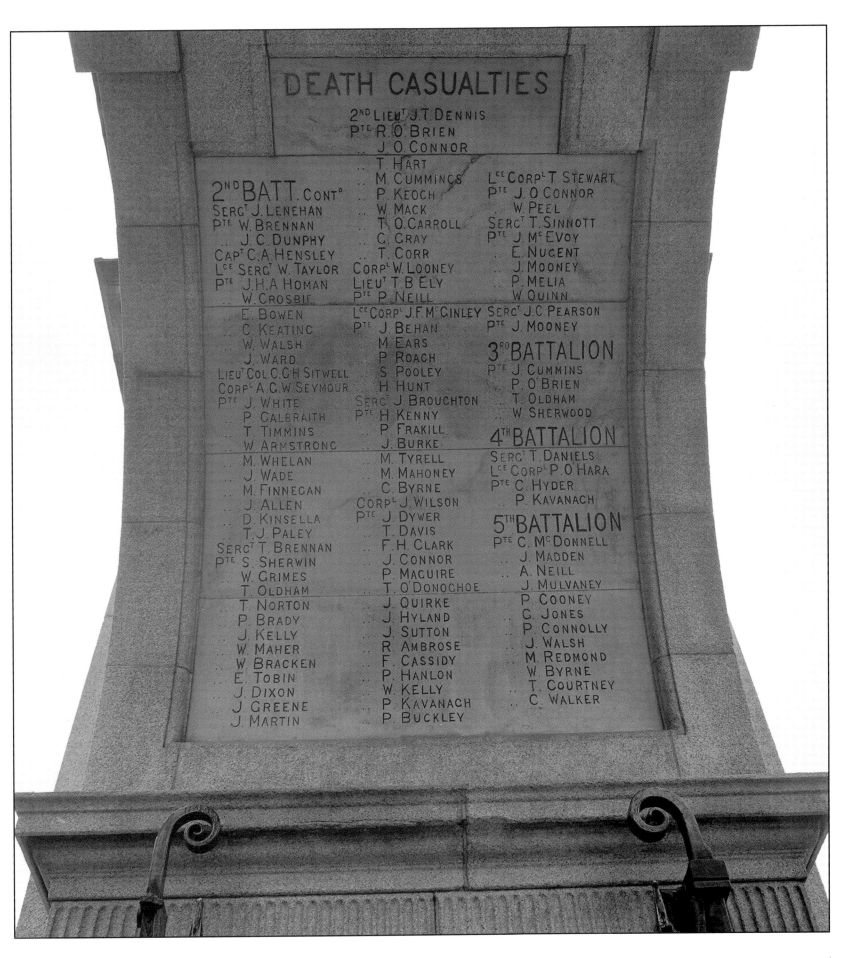

DEATH CASUALTIES

2ND LIEUT J. T. DENNIS
PTE R. O. BRIEN
.. J. O. CONNOR
.. T. HART
.. M. CUMMINGS
.. P. KEOCH
.. W. MACK
.. T. O. CARROLL
.. G. GRAY
.. T. CORR

2ND BATT. CONTD
SERGT J. LENEHAN
PTE W. BRENNAN
.. J. C. DUNPHY
CAPT C. A. HENSLEY
LCE SERGT W. TAYLOR
PTE J. H. A. HOMAN
.. W. CROSBIE
.. E. BOWEN
.. C. KEATING
.. W. WALSH
.. J. WARD
LIEUT COL C. G. H. SITWELL
CORPL A. G. W. SEYMOUR
PTE J. WHITE
.. P. GALBRAITH
.. T. TIMMINS
.. W. ARMSTRONG
.. M. WHELAN
.. J. WADE
.. M. FINNEGAN
.. J. ALLEN
.. D. KINSELLA
.. T. J. PALEY
SERGT T. BRENNAN
PTE S. SHERWIN
.. W. GRIMES
.. T. OLDHAM
.. T. NORTON
.. P. BRADY
.. J. KELLY
.. W. MAHER
.. W. BRACKEN
.. E. TOBIN
.. J. DIXON
.. J. GREENE
.. J. MARTIN

CORPL W. LOONEY
LIEUT T. B. ELY
PTE P. NEILL
LCE CORPL J. F. MCGINLEY
PTE J. BEHAN
.. M. EARS
.. P. ROACH
.. S. POOLEY
.. H. HUNT
SERGT J. BROUGHTON
PTE H. KENNY
.. P. FRAKILL
.. J. BURKE
.. M. TYRELL
.. M. MAHONEY
.. C. BYRNE
CORPL J. WILSON
PTE J. DYWER
.. T. DAVIS
.. F. H. CLARK
.. J. CONNOR
.. P. MAGUIRE
.. T. O'DONOGHOE
.. J. QUIRKE
.. J. HYLAND
.. J. SUTTON
.. R. AMBROSE
.. F. CASSIDY
.. P. HANLON
.. W. KELLY
.. P. KAVANAGH
.. P. BUCKLEY

LCE CORPL T. STEWART
PTE J. O. CONNOR
.. W. PEEL
SERGT T. SINNOTT
PTE J. MCEVOY
.. E. NUGENT
.. J. MOONEY
.. P. MELIA
.. W. QUINN
SERGT J. C. PEARSON
PTE J. MOONEY

3RD BATTALION
PTE J. CUMMINS
.. P. O'BRIEN
.. T. OLDHAM
.. W. SHERWOOD

4TH BATTALION
SERGT T. DANIELS
LCE CORPL P. O'HARA
PTE C. HYDER
.. P. KAVANAGH

5TH BATTALION
PTE C. MCDONNELL
.. J. MADDEN
.. A. NEILL
.. J. MULVANEY
.. P. COONEY
.. G. JONES
.. P. CONNOLLY
.. J. WALSH
.. M. REDMOND
.. W. BYRNE
.. T. COURTNEY
.. C. WALKER

Mary O'Rourke

The River Shannon, Athlone, Co Westmeath

Mary O'Rourke takes to the Shannon: 'it adds a special dimension to my life' (far right); the weir in Athlone (above)

Mary O'Rourke is Minister for Public Enterprise and deputy leader of the Fianna Fáil party. First elected for Longford/Westmeath in 1982, she has held many senior government posts including Minister for Education, Minister for Health and Minister for Trade and Marketing. Her late brother, Brian Lenihan, was also a prominent Fianna Fáil politician. Mary O'Rourke is married to businessman Enda O'Rourke and they have two sons.

Imagine a young child. A very young child. Maybe two or two-and-a-half years of age. There she is on the edge of a vast lake in the middle of Ireland. With her is her father. And what is he doing? Teaching her to swim. And, boy, is she determined, this young girl. She's not going to be left out. If her older brothers and sister are going out on the boat, right out on to Lough Ree, then she's going too. The problem is that there's a rule in this household - no one goes out on the boat until they can swim. So there she is, in the days before armband supports, determined to float free and strike out on her own.

'I remember it all,' says Mary O'Rourke. 'I can still feel my father's arms around me, supporting me, and I cold and shivery, from the weather and from the excitement.'

Her earliest memories are of the water, of the River Shannon and the lakes around Athlone. She was the youngest of four and the only one of the Lenihan children destined always to live on the shores of the Shannon. Her siblings had been born in Dundalk and in Tralee, 'and then one day my father came home and said to my mother, "Annie, we're going to Athlone".' For Mary O'Rourke, this was to become the central place in her life. But beyond the boundaries of the town itself, it is the water that continues to captivate her.

'My life is bound by the river,' she says, 'and by Lough Ree.'

Her father moved to Athlone to take control of General Textiles. 'It was like a state enterprise,' she remembers, 'and we lived in the middle of the factory, in what was effectively an old Protestant boarding school on the banks of the Shannon - fifty yards from our back door and we were at the water's edge.'

The family lived in an industrial atmosphere, with hooters going on site to alert the workers, so the presence of the river, with its calming, elemental influence was a real antidote to that.

Swimming played a big role in Mary O'Rourke's life. With her older siblings all going off on the boat for, what seemed to her, real adventures, she had, she says, 'an aching wish to be able to go off with them'. And learning to swim at such a young age meant that she could do just that. There's an image of the river that punctuates her conversation - brothers, sister, pals, maybe twelve or thirteen of them, all heading off for the day on the boat on Lough Ree complete with swimming togs, a picnic ('there always seemed to be banana sandwiches') and fishing rods. It's an idyllic snapshot of a river childhood.

When she was thirteen the family moved house, but stayed on the Shannon. Her parents bought an old Queen Anne house on the banks of Lough Ree and ran it as a hotel. Nowadays it's been somewhat Taj Mahal-ed as the Hodson Bay Hotel, but when the Lenihans were there, it was a more modest place altogether.

Again, Mary O'Rourke lived beside the water and grew to love it more and more. Eventually her father's small boat became a larger one, and she took up sailing. The association with water expanded and, although she readily admits that she hates swimming in pools,

(the chlorine and the imposition of bathing caps being just two of her bugbears) she did swim competitively throughout her university years at UCD. Nowadays she avoids pools, preferring to and take to the water only in rivers, lakes or seas.

She tells a story of her friendship with the former American ambassador to Ireland, Jean Kennedy Smith, another keen swimmer. 'Jean would often come down to Athlone and a friend would bring us up the river on his boat. We'd moor and the two of us would climb down the ladder and swim. She loved it, but I used to think sometimes, goodness, here I am, in the middle of the river, in hundreds of feet of water, swimming around with the American ambassador.' The notion that it might be a bit risky never really occurred to either of them, such was the enjoyment that it provided.

She has no fear of the water, no bad memories of storms or anything frightening ever happening to her. Rather she views the river, not as a threatening place, but as 'a place of comfort, a place I'd like to be at, in or on'.

Wherever she goes in the world, Mary O'Rourke likes to see the water, to observe the normal comings and goings on the waterways. When she's back in Athlone she really does have that sense of being 'at home'. And it is the water, she says 'that is the reason for that feeling - there's a lissomness about it.'

Within the context of her love of water is the love of her home town. 'I love Athlone,' she says. 'I know everyone in it - it's a town with no side to it at all. When I go home on a Friday night I look forward to going up town on Saturday morning to do shopping. I always park down beside the Shannon - I feel at peace and I feel at home.'

The town, she says, has developed its old left bank and the main street is now alive with new apartments, antique shops and the like - 'The town is looking to the river again. Turning its face in that direction. It's also a great barge town, with a lot of traffic on its waterways. There's an absolutely terrific sense of excitement about it all.'

Her love of the water has also been inherited by her sons: 'When Aengus was fourteen or fifteen,' she says, 'he discovered the water. Fishing rods were produced, fishing rods were lost, more rods were produced. He used to go fishing on the quayside in the middle of the town. Then he and a friend saved up enough money to buy a boat. They had three years of absolute bliss, going up the river, fishing, stopping off at the islands, lighting fires ... it really was an interest that focused him during what can be a difficult teenage period.'

And the Shannon continues to be her own focus - she recalls magic days spent with friends out on the Lough or in the small canals in and around Athlone.

'It's still my frame,' she says. 'it's the elemental nature of it that adds a special dimension to my life - maybe I wouldn't be able to take the slings and arrows of politics so well if it wasn't for it. The river, the water ... it anchors me.'

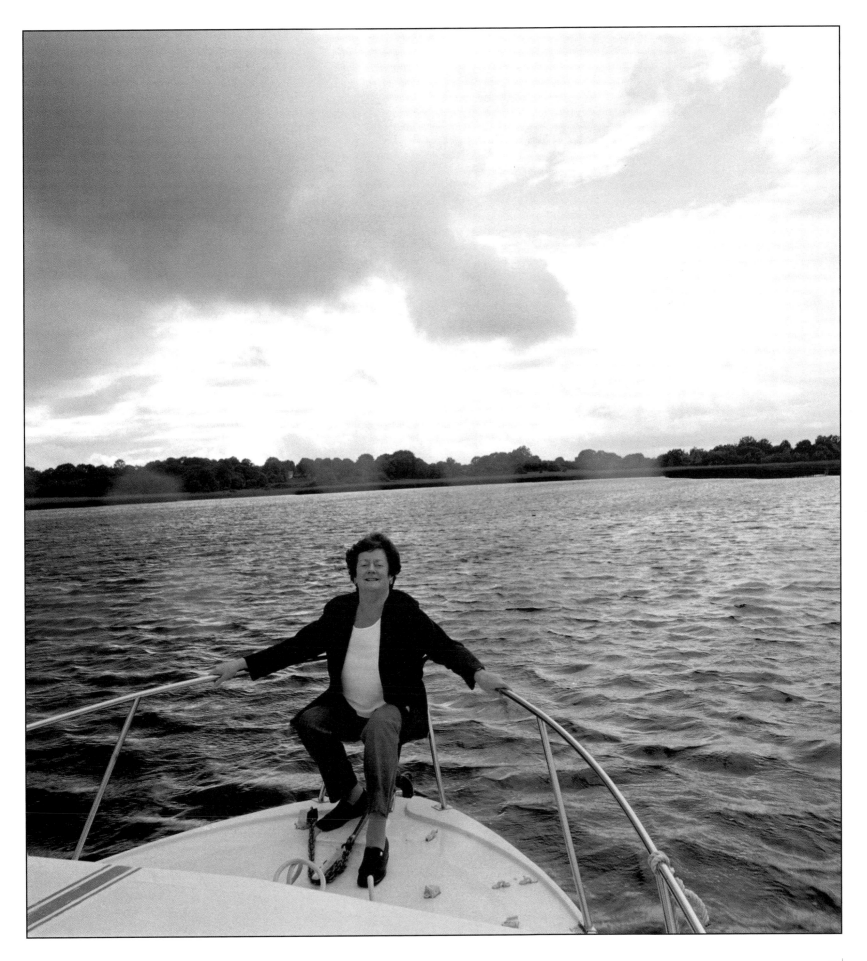

Helen Dillon

The Dillon Garden, Sandford Road, Dublin

Helen Dillon at the arched walkway (far right); statuary amid the foliage of her garden (above)

Helen Dillon is a gardener. Born in Scotland, she worked in the antiques trade before moving to Ireland thirty years ago. Her lifelong interest in gardening led to a regular column with *The Sunday Tribune* newspaper from 1992 to 1995. She presented RTE's *The Garden Show* and is the author of a number of gardening books. She lectures all over the world and has been awarded the Veitch Medal of Honour by the Royal Horticultural Society.

If Helen Dillon had pursued a life in the kitchen rather than the garden, she would no doubt by now be fondly referred to as 'One Slim Lady'. Like the two culinary ladies of a somewhat different physical shape, she shares, right down to her green fingertips, many of their most endearing qualities - humour, eccentricity, passion. (She is also, incidentally, Scottish, like the now, sadly, only remaining 'Fat Lady', Clarissa Dickson Wright.)

She loves gardens, is passionate about plants, travels the world to talk about things horticultural and to bring back exotic specimens from far-off climes. Yet, her greatest passion, and the place that truly reflects her own personality, is right outside the window of her buttercup-yellow drawing room in her Dublin home - her own garden.

Now, lest you think that this is a garden like yours and mine, it isn't. For this is the renowned Dillon Garden on Sandford Road, a gem of a place, lovingly created and cared for by Helen and her husband Val, and open for viewing to an oohing-and-aahing public during the summer months and at other selected times during the year.

'I feel settled here because of my garden,' remarks Helen. 'My life is centred around it. For years and years it was a new garden, then suddenly I woke up one day, realised I'd been here almost thirty years and that it had gone from being a new garden to being an old garden.'

Even in very early spring, before the profusion of colour takes over, the garden is an impressive sight. 'It's all so intensive,' says Helen Dillon. 'There are so many different seasons in the garden. Take crocuses - for two hours of the year they are incredible. That's it. Two hours. The sun is low in February, so they don't open fully- on rainy days they don't open at all - but for a very short time they are absolute perfection.'

She remembers vividly the day she first saw this Georgian house and its walled garden, all those years ago. 'It was late in the evening. We walked into the drawing room and looked out of the window. It was a very nice garden even then, but we've changed everything.'

She's also been responsible for changing people's attitudes to gardening in this country - with her incredible knowledge and no-nonsense approach she has educated us all. From her highly entertaining *Sunday Tribune* columns in the early 1990s, to her books and, in recent years, by way of the television screen when, complete with dungarees, trowel and her signature single earring, she took gardening by the scruff of the neck and knocked the stuffiness and elitism right out of it.

She has always been fascinated by plants although she's quick to point out that she never intended to become a gardening guru. 'In my teens I collected over 400 different geraniums. At school I always opted to work in the greenhouse instead of doing games and when I won an art competition I chose to go to Chelsea Flower Show as my reward.'

When she lived in London she was 'thrilled to get a garden'. Although only a balcony, it afforded her that much-needed contact with things horticultural. In a way, she says, she's become a victim of it all - always planting, always developing.

Her own garden may now have become public property but she talks about it in such a personal way that you sense its meaning in her life way beyond the shared canvas. 'There are so many memories tied up with it,' she says. 'Plants are connected with people. It's hard to throw away a bit of your past. I feel really strange looking at old photos - all those reminders ...'

She travels the world every year and fetches back seeds from far-flung corners, which she then propagates at home. New Zealand, South Africa, the Himalayas, South America - they've all provided much-treasured plant life for Sandford Road. She has a particular affinity with Patagonia, 'the wonderful emptiness ... it had a great effect on me'.

The garden itself is not huge - it comes in at just under an acre. Access is through a wooden gate and there it is, spread out before you: a wide green lawn, broad, well-planted borders and a series of 'sections', from the sundial garden to the arbour, to the pond and fountain area. Famous for its lavishly planted, colour-coded borders at the height of summer, Helen herself refers to her 'blue border', her 'yellow garden' and so on. There's a touch of impatience too. 'People have been trying to create colour gardens for the whole of the twentieth century. I've been doing it here for at least fifteen years. Now, I'm kind of bored with that. I'm always wondering, What's next?'

Yet there is so much that she obviously loves about the place: a particular spot which is very peaceful - 'It's for sitting in, the winter light is fantastic there' - her multitudinous collection of snowdrops of which she has more than fifty different varieties, her alpine house, her special plants like the *corokia* from New Zealand, her beautiful *auricula* which she bends to touch and refers to as 'a little sweety-pie'.

You get the feeling that she has a relationship with each and every plant in the garden. Many of them evoke strong memories and she cares for them as you would a child, or a much-loved older relative. She gets exasperated with them when they don't perform well and she worries about them when needs be. One particular one, an *echium*, has been causing a few problems. 'It really is rather poor,' she says, looking at it with furrowed brow. 'I was thinking about it during the night.'

And when she really stands back in an attempt at detachment, when she surveys the honeysuckles and the roses, the hellebores, the New Zealand daisies, the exotic plants, the fragile seedlings in the greenhouse, the fifty different snowdrops, the shock of colour in the summer, the momentarily stunning crocuses - where or what is her favourite bit?

'Oh,' she says without hesitation, 'right down the back, as far as you can go, looking back up towards the house. That's the place, of course, that's furthest away from trouble.'

Gavin Friday

Gavin Friday at the Sacred Heart: 'JC has survived' (far right); Charles Stuart Parnell (above)

Gavin Friday is a singer/songwriter. He was the founder and lead singer of the punk band, The Virgin Prunes, with whom he recorded albums such as *Shag Tobacco*. As a solo composer he has written theme music for a number of films including *In the Name of the Father* and *The Boxer*. He had an art exhibition in Dublin in 1988. He is currently in studio working on a new album.

O'Connell Street, Dublin

'**My Uncle Paddy** always called it "The Street of the Three Adulterers",' laughs Gavin Friday. 'You had Daniel O'Connell at one end, Nelson was there on his pillar in the middle, and then Parnell. Now it's one big whore, one big painted whore, with the yellow and red of McDonald's and all the other garishness of the street.'

Yet it remains special to him, this former punk rocker who still looks every inch a rock star as he sits amid the bustle of the lobby of the Gresham Hotel. 'I love Dublin. I love O'Connell Street. It's our mother street. She might have turned into a bit of a tart but she's still our mother after all.'

Describing himself as a 'die-hard northsider', he was born forty years ago in the Rotunda, at what he calls 'the butt-end' of O'Connell Street. 'Brendan Behan always used to say that if you were born in the Rotunda, then you were a true Dub.' Growing up in Ballymun, Gavin Friday found little to ignite his imagination, little to excite.

'My true mecca was O'Connell Street,' he explains. 'As kids we'd get the 19 or the 19A bus into the city. It stopped at Clery's, which, in its heyday, really was something.' Nowadays in New York, he says, 'you'd be standing in Macy's looking around and thinking to yourself, this is like Clery's used to be.'

His memories of the street when he was a child come flooding back – how it looked, the beauty of the buildings, what parts he liked best, where they used to go. 'Findlaters,' he recalls, 'where that awful Eircom building is now, was a ginormous delicatessen. I remember the huge glass staircase. Occasionally, instead of Calvita, my mother would buy sliced cheese, and in Findlaters they'd give us kids a bit to taste. Then there was Fortes. Actually there were two Fortes – one near the Savoy cinema and another near where the Ann Summers shop is now. The knickerbocker glories were fantastic. We'd come in on the bus [Gavin Friday is the eldest of four boys] after our First Communions or Confirmations and straight into Fortes for the knickerbocker glories. Each table had individual juke boxes and I remember that the women who served you all wore blue uniforms. It was like something from *American Graffiti*.'

Nelson's Pillar isn't a strong memory, ('although there was a bit of rock from it on my Da's mantelpiece at home'), but the Easter Parade was a big thing in his childhood. 'My Da would bring us in on the bus. There they'd be, the Irish Army, with one tank and a few guns. I can remember being up on my Da's shoulders, waving a tricolour. It was toys for boys.' And now it's gone, banned when the Troubles were raging in the North. Gavin Friday thinks the banning was a mistake because it was, he says, 'a celebration of our independence' .

You can tell that he regrets the change in O'Connell Street. It's still an emotional landscape for him. 'When you walk into the GPO,' he says, 'apart from it being a beautiful building, you still get a whiff of how cosmopolitan, how European a street this once was. There are only a few buildings left now with that kind of glamour'.

On he goes in nostalgia mode, thinking back, remembering details about the street – the Capitol cinema at the laneway beside the GPO, a thin-looking building 'like something in Manhattan', the ballroom close by, also long gone, Easons and how 'it used to be an incredible store. Now you go in and you don't know where to find a book'.

Some things remain, of course. McDowell's Jewellers, The Happy Ring House is, he says, 'one of the most extraordinary pieces of neon', and then there's the constancy of the River Liffey. As a teenager he was very conscious of how the Liffey divided the city into north and south, fearful, almost, of actually crossing the river to the unknown territory of the other side. 'We heard that there were universities over there,' he says, 'and different kinds of people.' Then came punk. 'Around 1977 we were all dressing in a certain way. Rumour had it that across the river in Grafton Street there were punks as well. So over we went, but it was our music that gave us that confidence. And do you know what? We were cooler and we were better.' After his band The Virgin Prunes stopped performing, Gavin left music behind for a year and painted instead. At the end of that year he had an exhibition, and yet again the river raised its head in his consciousness. The exhibition was entitled, 'I Didn't Come Up the Liffey in a Bubble'.

Nowadays, thinking of that original northside/southside divide, he laughs when he tells you that of his original group of friends, including those who are now U2, 'only myself and Larry Mullen have stuck to our guns. We still live on the northside. All the others have sold out and moved south! I live in Phibsborough, it's a great place – beside the zoo, the President and Grangegorman, what more could you want?'

Almost a quarter of a century since those heady punk days of the late Seventies Gavin Friday still retains his emotional attachment to O'Connell Street, abhorring what he calls its 'absolute annihilation, and the rise and rise of McDonald's culture'.

'I look in shock at it all – you go to Paris or Rome and, yes, they have McDonald's and the like but look at how they handle it – the M is in gold and the building is in marble. Just look at our main boulevard! Why are we allowing it? I was outraged by the Ann Summers sex shop. I'd like to give the whole project to someone like Senator Norris to sort out. I mean, somebody has to do something. What do they do when they're driving some head of state through our capital city? Take a detour to avoid O'Connell Street?'

Yet he loves the bustle on the street and, despite initial reservations about what he calls the 'legobox' aspect of the fountain, he also likes Anna Livia very much. He knows all its nicknames of course but refers to it only as Anna Livia, making a point of alluding to its Joycean heritage. Having a water feature on our central thoroughfare appeals to Gavin Friday, especially the fact that it gets crowded with people, that it has become a meeting place for all ages. And, although he is unhappy that it has become

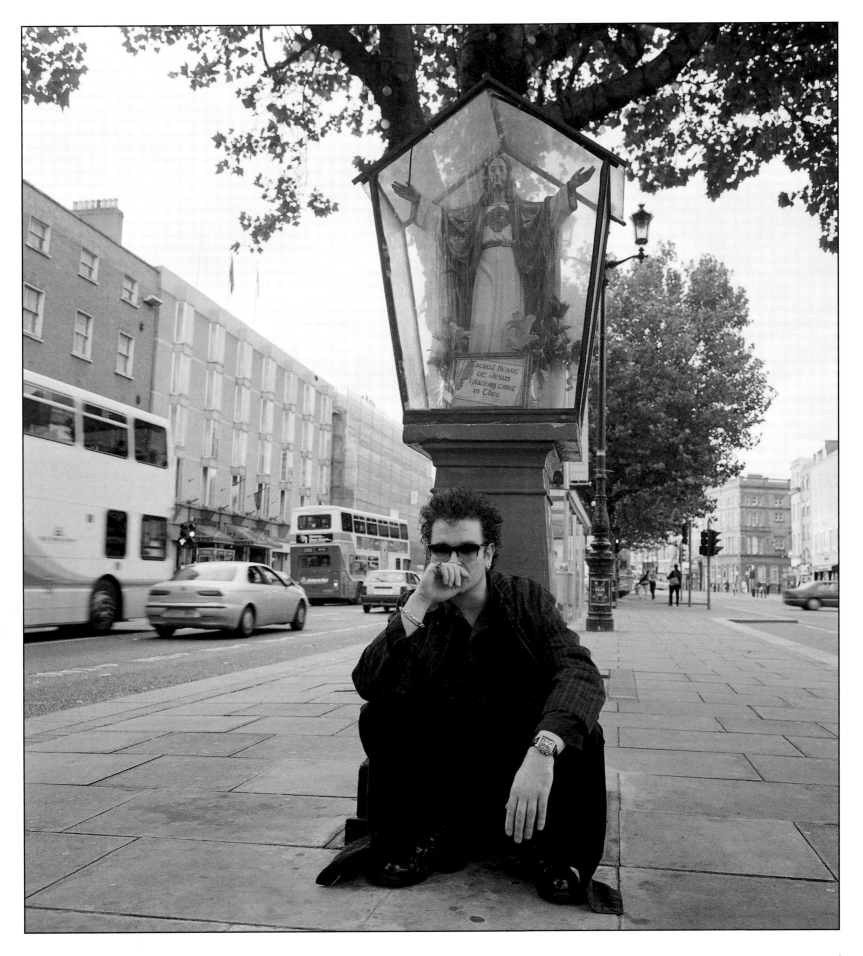

Anna Livia: 'our own
Speakers' Corner' (far right);
Daniel O'Connell looks
towards the southside: 'we
heard that there were
universities over there' (right)

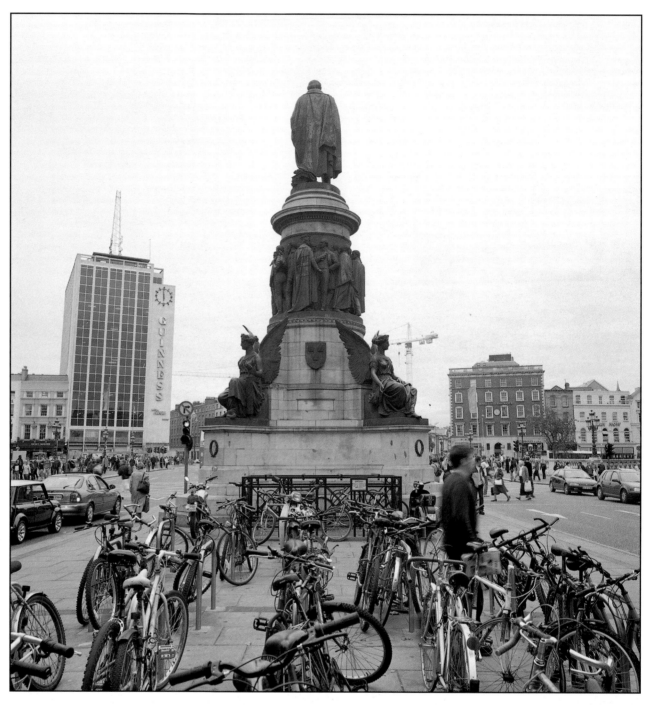

a platform for anti-abortionists and Marianists ('Holy Mary of O'Connell Street is always there') he likes the notion of it being our own Speakers' Corner.

The force of Catholicism is still strong on the street – 'almost surreal,' he thinks. 'When you look at how O'Connell Street has been desecrated,' he says, 'and yet the Sacred Heart statue beside the taxi rank is untouched. You'll be queuing for a taxi sometimes and you'll see keys left at the foot of it for safekeeping. So much has been destroyed and yet JC has survived.'

So, apart from getting David Norris on the job, is there any hope for this great boulevard?

'Yeah, I think there is hope. I mean, they haven't knocked down the GPO and the Ambassador is still standing.' And yes, despite his penchant for things past, he also likes the idea of the new Spike for O'Connell Street, likes what it says about Ireland – a new, forward-looking, modern country; a new monument on a street that should reflect Ireland, past and present, a symbol that is artistic and positive, rather than blatantly commercial and tacky.

Finally, he tells a story that illustrates how important O'Connell Street is to him. 'I was watching Neil Jordan's *Michael Collins* movie,' he says, 'and there it was in the opening scene, the destruction of O'Connell Street. Blown to bits. I remember sitting there, watching the screen and feeling an emotional knot inside me. Look what they're doing to our street, I was thinking. It was as if it was real for me. I don't think you can ever quantify this street's relevance, how important it is in the Irish psyche.'

If Senator Norris is too busy, maybe there's another candidate willing and able to return O'Connell Street to her former glory, someone who feels passionate about turning the painted whore back into a grand old dame again.

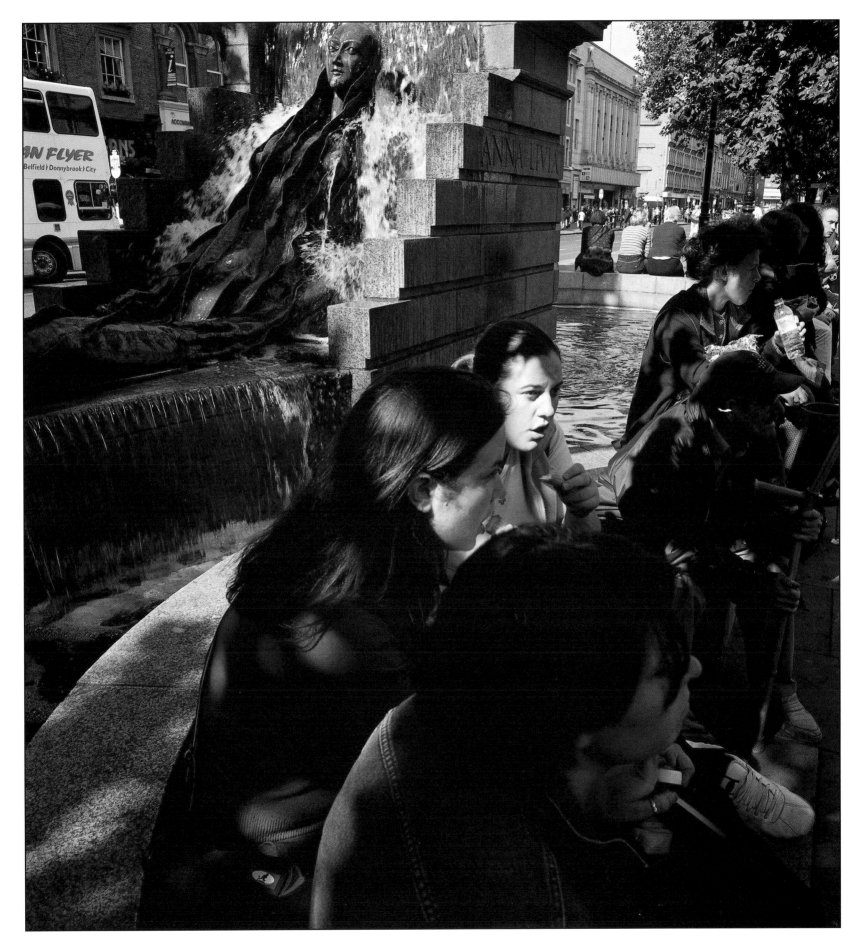

Evelyn Conlon

Miltown Malbay, Co Clare

Evelyn Conlon in Qually's bar in Miltown (far right); just off Spanish Point (above)

Evelyn Conlon is a novelist, short-story writer and a commentator on the arts. Born in Co Monaghan and educated there at St Patrick's College, her first collection of stories, *My Head is Opening*, was published in 1987 by Attic Press. Since then she has published further collections including *Taking Scarlet as a Real Colour*, along with novels such as *Stars in the Daytime* and *A Glassful of Letters*.

Miltown Malbay is not just a town. It is not just a landscape either. 'It's a notion,' says Evelyn Conlon. 'In the beginning when I first started coming here, it was just the geography of it that appealed, but as I visited more and more, it became other things.'

This small town, situated right out on a headland in Co Clare, is dominated by the sea and that sense of openness which proximity to the ocean always brings. It's also a place that has a tendency to set your feet tapping, for Miltown Malbay's big claim to fame is as a centre for traditional Irish music. Musician Willie Clancy lived here, and the Summer School named after him is hosted by the townspeople annually in July when musicians, students and aficionados come from all over the world and set up camp here for a week.

'I was brought here for the first time around 1980 by Fintan Vallely,' explains Evelyn. 'I didn't even know where it was on the map, let alone anything about its musical heritage.'

So what was its immediate appeal?

'What struck me first was its actual location - the town itself is about two miles inland from Spanish Point, a part of the coastline where you are right in the sea. I remember the roughness of it - it was winter at the time. There was also a strange feel about the place; in a way I knew immediately that I would keep coming back here.'

And back she came, time and again, every year. Then she brought her two young sons with her and, as is the case with all small children, the long distance was difficult for them. 'At the Red Cow Inn [on the Naas dual carriageway just outside Dublin] my youngest son would ask "Have we far to go still?",' she remembers.

At first they camped, then it became B&Bs, after that it was a house that had been a cow shed and which, Evelyn says, 'was almost to become our home.' She means their *real* home, not just a place for the holidays. But, although that lifestyle change didn't materialise, even as her summer home Miltown Malbay was to become a huge focus in her life, while for her children, it became their childhood country.

The memories that endure are all images from that time, she says - 'My initial reactions have lasted.' These images are largely two-fold - one is of the sea itself, of its sense of freedom, and the other depicts a different kind of liberty of which Evelyn Conlon had no real experience before Miltown Malbay entered her life - that which comes from music.

'I've heard the most wonderful music here, both at concerts and at sessions in small pubs throughout the year. When my kids were young I was able to bring them with me into some of the pubs. It was all so relaxed compared to how I lived my life in Dublin - you weren't in a pub just to drink.'

It was in Miltown Malbay that she became 'educated in listening to traditional music. I was like everyone else - I thought I knew tunes but it was there that I realised that people need to be educated. You have to learn how to listen.'

The high note of the town's musical calendar is of course the Willie Clancy Summer School. 'Walking up the street during that week,' says Evelyn Conlon, 'is like pushing your way through a carnival. The whole thing is an extraordinary feat of organisation. The atmosphere is wonderful - you'd be walking up the town and you'd hear people practising away inside - flutes, fiddles, whatever ... you hear it all.'

The one-street town is a hive of activity during the July week. Classes, lectures, concerts, flute sessions, singing ... it is, says Evelyn Conlon, 'the most wonderful afternoon or evening you could fall into during your life'.

Music apart, Miltown Malbay's other strength is, of course, its location on the edge of the Atlantic ocean. The best things, according to Evelyn, are the walks around the sea. She loves Spanish Point, the feeling of escape it brings. As a writer, she finds it conducive territory. A section of *A Glassful of Letters*, her latest novel, was written here. Part of that story was told through an exchange of correspondence between Ireland and America and so 'it seemed an appropriate place to be writing those letters - after all, the next stop out from this coastline is New York,' says the author.

So Evelyn Conlon likes to write here, to immerse herself in whatever world she is currently inhabiting for whichever book she's working on. But then she loves to set her work aside, 'the glorious relief,' as she calls it, 'of leaving it and going outside into a separate world'.

She recounts a heart-warming mother-and-son story about Miltown. 'One of my most special weeks here was just before my eldest son's Leaving Certificate. We came together, just the two of us and booked into a hostel. Each morning, we set out and drove a bit up the coast.' Then they parked the car, found a beach or a headland and walked together, discussing topics from his various school courses. 'Then,' she says, 'we'd have a bar lunch, go back to the hostel, he'd do some more study and I'd work as well. Then at night we'd go out together and hear a few tunes.'

Today, twenty years on from when Evelyn first became intoxicated with this little town, her major regret is that she doesn't spend enough time here. 'I do in my imagination, though. Sometimes, when I'm driving back from a working trip or whatever, I get the urge to take the wrong turn on the road and end up in Miltown Malbay, instead of back in Dublin. It represents total escape and yet I have a familiarity with it - the only other place I feel like that about is Monaghan, where I come from.'

From her very early visits, Evelyn Conlon knew that, in the future, she would keep coming back. And now that that future is the present, she's looking further ahead again. 'I will always come back,' she says, with the quiet determination of someone who has firmly decided on a set course, 'and I will be buried here. There's a particular spot in the sea just north of Spanish Point. I rather fancy it as my final resting place.'

John Kelly

Lough Erne, Co Fermanagh

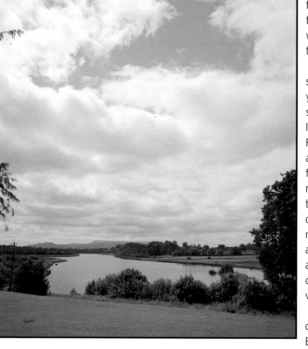

John Kelly amid the rushes, down by the water's edge (far right); a view of Lough Erne (right); across from Devenish Island (above)

John Kelly is a journalist, broadcaster and novelist. He attended Queens University Belfast and has produced and presented television programmes for the BBC, Channel 4 and UTV. He presents *The Mystery Train*, an eclectic nightly music programme on RTE radio and is a columnist with *The Irish Times.*

Although he is constantly drawn to the waters and the wild, John Kelly readily admits that he is 'a townie'. Born in Enniskillen, Co Fermanagh, he explains that you can come from a town that is still quite rural. Enniskillen is precisely that kind of place.

'It's not all tarmac and concrete,' he says. 'There are fields nearby. I mean, Enniskillen is an island in the middle of Lough Erne. There is water all around.'

As a child, he was, 'always at the water ... Instead of hanging around street corners, I went fishing with friends. Later, as teenagers, we'd go off up Lough Erne. We weren't *anglers* exactly. Anglers were the English and German people who arrived with their big umbrellas and their wicker baskets. Initially all we had was a hook on a line and a float that was so big no fish could have pulled it under!'

Then a teacher came to the rescue; Pat Lunny was his name, and he taught John Kelly a few of the basics. 'We also picked up a few tips from the anglers,' says John, 'but they'd be really freaked by us pulling things in - roach, bream ... Then we'd use the small fish we caught as bait for pike; we'd lie on the banks of the Erne with the rod in the air, like something from *Jaws* and stay like that all day.'

As a teenager, John Kelly knew all the names of the plants, the birds, knew the different bird calls. It's a knowledge that has stayed with him. 'You learn the rhythms of that kind of environment,' he says. 'I still love to get out on the Erne. When I go back home, Pat Lunny takes me out on his boat. The nature of my celebrity is not huge by any means but sometimes I find that it's nice just to get away from it all for a while.'

His own 'patch' on Lough Erne is the Lower Lough, the northern end of the water - out past Portora school and on up past Devenish Island. He loves the tranquillity of the place. 'Really early in the day it's like the Rain Forest. The only sound is birdsong.'

As an only child growing up in Enniskillen, John Kelly acknowledges that he had the space to pursue his love of the wild, without the extra demands of siblings to be accommodated. His parents still live in the Fermanagh town and he still returns home to visit. Nowadays he doesn't miss the fishing itself as much as 'the silence of it'. He keeps meaning to go back, row out to one of the islands, set up camp and stay a few nights. He recalls the sights, the sounds, the smells of the place. 'The scent of the wild garlic is extraordinary. And, in early summer, the sight of the bluebells ... the light is actually blue. It's like something from Disney's *Bambi!*'

The lough is a reminder of a happy childhood. 'Things were a lot simpler then, but there is a sense of continuity which remains intact.' He reminisces about the scaffolding of his Fermanagh childhood - the fishing, of course, the climbing trees, the building forts. 'We'd build a fort,' he says, 'and then we'd just sit in it. We got our inspiration from the comics of the time - you'd get free compasses, tips on survival, "how to catch a fish with a safety pin", all that sort of thing.'

Particular memories remain strong. 'Every time you'd go out you'd see something you hadn't seen before. One night, it seemed like, suddenly, all the swallows in Fermanagh were flying overhead. I also remember really clearly the first time I heard a snipe. When they mate they go up high in the sky; then they fall suddenly and, as they descend, they make a distinctive noise with their tail feathers. You're always surprised by something out around the lough. It's also, of course, a great way to show off to visitors!'

Talking of visitors, he recalls once persuading a friend from England just to sit still on one of the islands and watch for the hares. They sat there, silently, for a long, long time. 'Afterwards the guy said to me, "I can't believe I've just spent three hours looking at rabbits".'

It's those kind of moments that keep drawing John Kelly back to the Erne. And, even though he's not there anymore, he still carries it with him in some way; carried from his childhood through to his adult years, carried from the wetlands of Fermanagh to the city streets of Belfast, Dublin, or wherever he happens to be.

'Of course I miss it,' he says. 'But I love walking wherever I am - I take the binoculars, go out and see what's happening. I don't run around with a notebook or anything like that. But even today, what I learned around the Erne passes the time for me. Even if I'm on a station platform, waiting for the DART, I'm walking along the hedge, having a look, trying to see what's living inside.'

From water to tarmac, rural town to cosmopolitan city, journeying still around his childhood.

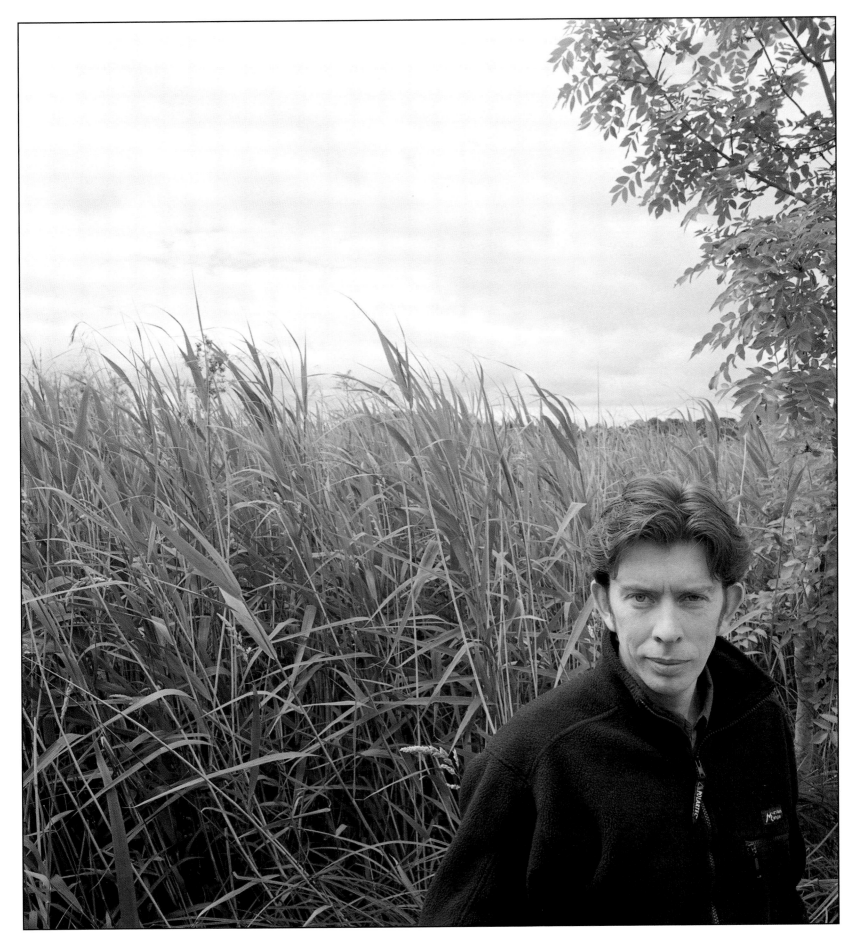

Brian O'Driscoll

St Anne's Park, Clontarf, Dublin

Rugby pitches are notable by their absence in St Anne's Park. Yet for Brian O'Driscoll, this is the setting that started him out on the sporting life which has earned him his place in the history books as an outstanding international rugby player. It is the place he associates most strongly with the love for sport which he developed from an early age. It's also only a stone's throw from the house in which he grew up; in a couple of minutes he could be in the park, kicking a ball, even if, in those days, it wasn't necessarily of the oval-shaped variety.

'A great deal of my associations with St Anne's,' he says, 'are to do with being young and playing sport there. I've always been a huge fan of sport and when I was a child I'd spend hours and hours in there, just kicking a ball by myself or with friends.'

At first it was Gaelic football and Brian played on teams there from the Under-8s up until the Under-14s. The Gaelic pitches were those closest to his house, so there must have been a feeling of familiarity, of security almost, for the very young Brian O'Driscoll, as he played in the shadow of his own home. Later came soccer and it was again St Anne's where he began playing competitively for the junior Clontarf teams.

But because of the proximity of his home to the park he has other recollections, ones relating directly to his family, especially from early childhood. There is a particular connection with the park's famous Rose Garden, which is strangely at odds because that part of the park never held any real appeal for the older Brian O'Driscoll. It's the place, after all, where as a teenager he would take the family dog for a few quick laps of the rose bushes, simply to get the chore of walking the hound out of the way. Yet for the young boy of seven- or eight-years-old, the Rose Garden held a special association, with the woman he refers to as his Cork granny.

'She would come up from Cork every now and then to visit us and I remember clearly going for walks with her in the park, through the Rose Garden which she loved, and then taking different routes that would bring us down on to the coast road. The ritual then was to stop at the corner shop for me to get sweets before making our way back home. I remember that it was only ever the two of us, just me and my granny.'

Brian's father, on the other hand, got dragged out to play Pitch 'n' Putt on the small course beyond this beautiful garden. 'I'm an avid golfer,' explains Brian, 'and I used to buy a season ticket for the St Anne's course every year. If I couldn't always persuade my Dad, then I'd play with friends.'

Sport once again. And boys' 'stuff', of course – remote control aircraft displays at the carnivals that took place there, taking part in summer treasure hunts, riding BMX bikes with pals through the wild, untamed part of the park that stretches up from the coast road. Up and down the steep inclines, seeing who was the most daring – all memories of boyhood with the park as the backdrop to whatever particular activity was the order of the day.

Those familiar with St Anne's will know what lies within the confines of its huge acreage – the mile-long, ramrod-straight path that leads to where the house on the once-private estate originally stood, the sports pitches with their weekend clamour of activity, the manicured Rose Garden, the old walled garden beside the arboretum, and then the area that stretches beyond, right back through the unkempt wildness to the pond near the coast road at Clontarf. It is a playground for leisure and relaxation – 'a park in a city,' as Brian describes it, 'an invaluable resource, covering such a vast area and providing great pleasure for so many people. We're so lucky to have it and yet we take it for granted.'

And it is still a force in his life, not just the seat of nostalgic memories from his childhood and teenage years, bearing no relation to his present life as a professional international rugby player. He still lives in the family home beside St Anne's and still uses the park as his playground, training ground – call it what you will. 'Yes,' he says, 'I still go in there. Go across to the Gaelic pitches. When I'm training, I run in St Anne's or sometimes I just take a ball across and practise my kicking.'

And who knows what that might bring in the future ... from St Anne's Park to other rugby parks around the world, kicking Ireland, and himself, into the record books.

Brian O'Driscoll on his first training ground (far right); the pond near the coast road (right); ruin near the arboretum (above)

Brian O'Driscoll plays rugby for Ireland. He made his debut on the Australian tour of 1999 when he was unanimously voted Player of the Tour by the Irish squad. His hat-trick of tries against France in the Six Nations tournament of 2000 brought him international acclaim. He grew up in Clontarf, in Dublin, where he still lives.

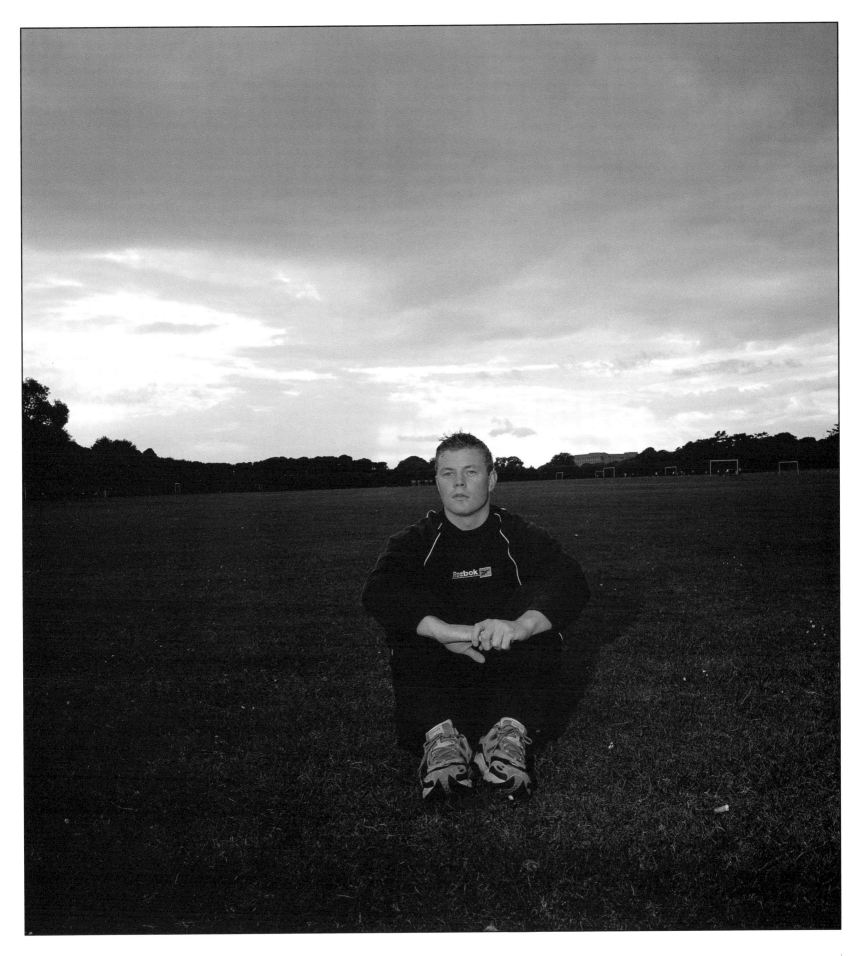

Inez McCormack

The Belfast to Derry Road

Inez McCormack beside the road that represents 'all kinds of awakenings' (far right); the ever-welcoming Ponderosa on the Glenshane Pass (above)

Inez McCormack is the first Northern woman President of the Irish Congress of Trade Unions. Active in the Civil Rights Movement in the late Sixties, she has a long track record of service on equality and human rights and is currently a member of the Northern Ireland Human Rights Commission. She has contributed to a number of human-rights publications. Married to Vincent McCormack, they have one daughter, Anne.

Seventy odd miles isn't really that far. Belfast to Derry, Derry to Belfast. Past Randalstown and Toome, skirting Magherafelt, Maghera, close to Draperstown and Desertmartin and on into the Sperrin Mountains, through the Glenshane Pass towards Dungiven and on into Derry. Seventy-three miles exactly, according to the road map, not a huge journey when you think of it.

Distance, though, isn't always measured in miles. For Inez McCormack, it's been a physical and a spiritual journey, which has taken more than thirty years, on a road to awareness that she is still travelling. It may not be, physically, quite like Robert Frost's 'road less travelled' – she has actually driven along this road many, many times – but in terms of personal and political awakening, it has often been a lonely road, a road of ups and downs with many forks and no clear signposts.

From a Protestant, working-class Belfast background, Inez has been married for many years to a Catholic man from working-class Derry. For her the journey between the two destinations is more than just a line on a road map. 'In personal and political terms', she says, 'the road to Derry represents all kinds of awakenings in my life.'

As a young child she journeyed with her parents from Belfast to Derry, and further still, into north Donegal, to Carrigart, her mother's home territory. She still remembers being told 'to hide the butter' crossing the border, and being 'riven with fear' in that childlike way.

As she got older, the well-trodden route changed, bringing her into contact with new situations, new ideas. At sixteen she left both home and school and struck out on her own, working as a typist and clerical assistant. In her spare time she studied for her O Levels and A Levels, applied to Queens University and was provisionally accepted. But she failed her O Level Maths, and so, unable to take up her position there, found herself instead signing up for student life at Magee College in Derry. She took her first significant step on the Belfast to Derry road and started a new life in the city on the Foyle.

And what a different life it was. 'I was from a strongly Protestant background,' she explains, 'and I had no idea what was going on – the demonstrations, the inequality. This was my first real awakening. We were even warned, when out for the night, never to walk back to college through the Bogside's Lecky Road. Derry signalled changes in my life. I wasn't radicalised then, but I was becoming aware.'

Off she went to London after college where, in a pub on the Earls Court Road, she met a young man from Derry. With money that he'd made from bar work and some that she'd accumulated from, as she puts it, 'getting sacked from every temping post around London and doing a bit of part-time modelling for Biba' they headed for Europe together. 'It was that summer of 1968, the summer of no responsibilities. We hitched around Europe and there we were in Portugal in the October when onto the TV screen in the bar came images that made Vincent [her future husband, Vincent McCormack] turn white.' What they watched together on the screen on 5th October 1968 changed everything. They saw Vincent's community

(on the Lecky Road), under threat, his people set apart. 'We hitched home. It was the end of innocence, the end of freedom. We went back and became involved in the civil rights movement ... and that's a journey that's still going on.'

The road rose up again in her life with the famous Belfast to Derry civil rights march on New Year's Day 1969. There, in the now legendary incident at Burntollet Bridge, the marchers were ambushed by loyalists and many were beaten and injured, Inez McCormack among them. It was the biggest eye-opener yet. 'I went home after the march that weekend,' she remembers, 'home to my own community, and all I can say, the only way I can describe it is that the mask came down. Nobody wanted to know. It was a revelation to me and I found it really, really shocking. The night in the Bogside when Sammy Devenney was killed [he died some weeks after the incident as a result of his injuries] all the families in the Lecky Road left their homes and went up the hill. I'll never forget watching the humiliation on their faces.'

In the early 1970s Inez McCormack joined NUPE, the public service union, and in 1976 she became a full-time official and its first woman officer. The North-West was her patch and the Belfast to Derry road the main artery along which she travelled to do her job. At her interview (for which she dressed cleverly to disguise the fact that she was pregnant) she was asked how she would feel about having to handle a meeting in the London docklands. She had no problem with that, she told them; after all, she was well used to driving the Derry/Belfast Road, on her own, at one or two in the morning.

All kinds of memories from the late Seventies and early Eighties are evoked by this part of the North. During the anti-Thatcher health strike in 1982, Inez would get up before five in the morning and drive around to lend support to those on the picket lines. She did that two or three times a week. Derry's Altnagelvin Hospital has a special resonance.

'I'll never forget the Altnagelvin picket line,' she says. 'The cheerfulness of those women, women who were being paid buttons, yet were finding themselves.' Even today, when she travels the road and sees the tower blocks of the Altnagelvin looming into the skyline, it brings her back to those days in the Eighties when so much was at stake, a time in her life which was, she says, 'about articulating and understanding equality and human rights'.

On a purely personal level the road also holds great significance for her. When her daughter Anne was a young child the family often journeyed to Derry. 'It was very important in her childhood,' she says. 'My daughter and my husband's mother adored each other. My mother-in-law's wee weakness was the penny slot machines in Buncrana and when Anne was young they used to play them together. When my daughter was older she used to go to Derry and, although not very religious herself, she'd take her granny to mass on a Saturday evening. When my mother-in-law

Burntollet Bridge, scene of the 1969 ambushed march (far right); Derry, and the Altnagelvin hospital, loom out of the distance (above)

died, Anne came home to Derry to help carry the coffin and bury her granny.'

Then when her daughter left home it was Inez and her husband who had to cope. They bought a second home in Donegal's Inishowen, a place that they love, and found that helped to fill the void.

Cycles repeat themselves. Old habits are hard to break. Inez still crosses the Burntollet Bridge when she's on her travels. She still drives to Donegal, now to her own home, not that of her mother as she did so often when a child. And right at the top of the Sperrin Mountains, in the Glenshane Pass, the Ponderosa pub is still her port of call. 'I've stopped there so many times over the years,' she says. 'The fry is practically on when they see me coming in the door! I love it because they always offer you the civility of not crowding you.'

Now, with the home in Donegal, Inez McCormack is on a new journey. It's what she calls 'a journey of my heart'. The road no longer runs only to Derry, but to Derry and beyond.

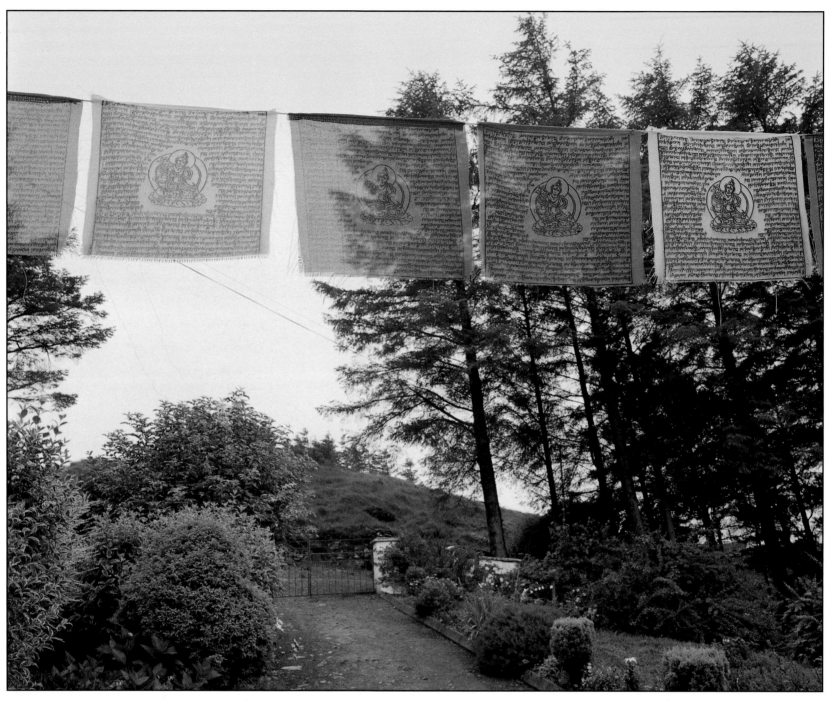

The black lake with its *dobhareach* (far right); the Tibetan prayer flags around the bungalow (above)

so that the darkness of the lake and the sense of being led away into its depths represented, for her, an entrance point to her own dark world. It is a powerful image as you look out across this stretch of water and realise the force that there is in the duality of things.

Yet up the road, this old bogland ruin that is the station of Caiseal na gCorr retains such power over Cathal O Searcaigh that it is the subject of one of his poems and, in an English version translated by Gabriel Fitzmaurice, he refers to it as the place where he found 'my hidden island, my refuge, my sanctuary'. From this vantage point, he writes:

Here I feel permanence
as I look at the territory of my people
around the foot of Errigal
where they've settled

for more than three hundred years ...
This is the poem-book of my people,
the manuscript they toiled at
with the ink of their sweat ...

You sense that it captures for him all that blending of his heritage, from his mother's private battles with the dark to his father's constant homecomings; from his people's changing fortunes to his own personal awakenings. He loves especially to sit at the ruined station and achieve an almost trance-like state of heightened awareness by reciting a mantra of local place names ...

'By doing this,' he explains, 'I become better attuned to my *duchas* – my cultural endowment from my people's past. At Caiseal na gCorr I try to bring the past into the present so that there will be a future for that past.'

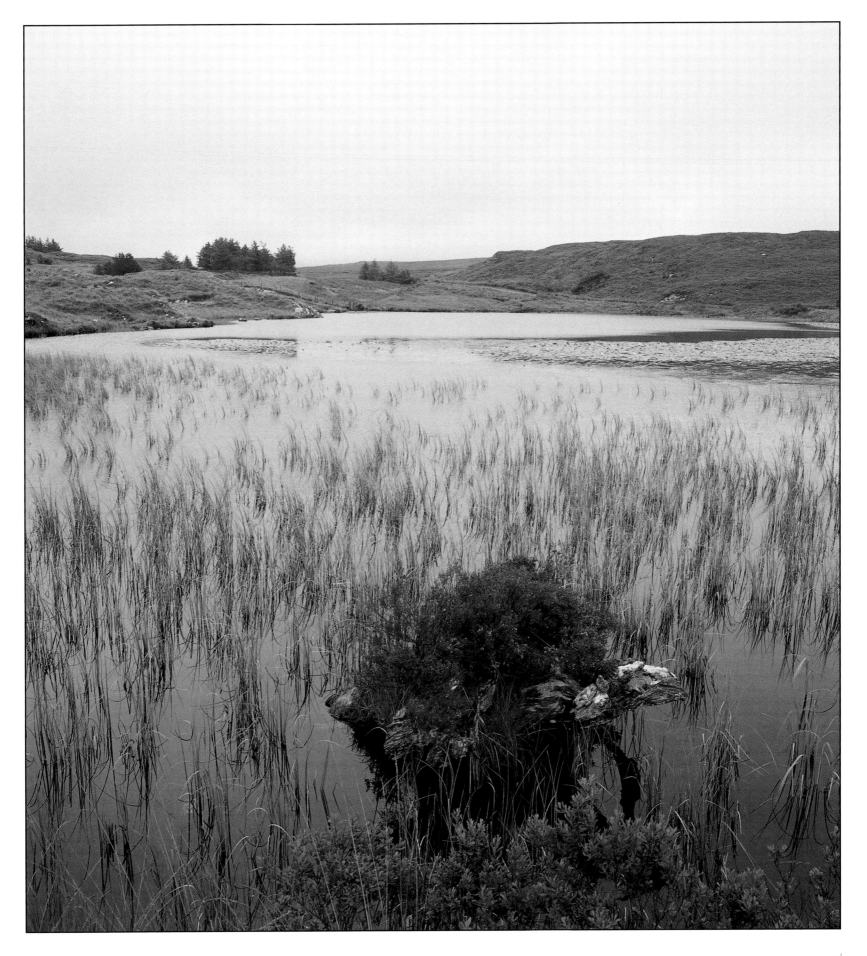

Ruairí Quinn

Sandymount Strand and Sandymount Green, Dublin

Ruairí Quinn on Sandymount Strand: 'with land, sea, and sky all merging' (far right); Sandymount Green (above)

'It's at its best in winter when the light comes in at a horizontal level and illuminates the whole bay like a spotlight. It's like an envelope with land, sea and sky all merging. Oh, you might detect a slight line, alright, but it is that merging that is so distinctive.'

Ruairí Quinn's description of Sandymount Strand, with its merging lines and its unusual light, is as evocative as a painting by the artist Felim Egan who takes much of his inspiration from the strand in question. It's a particular vista which, through literature and art, has become synonymous with Dublin, one of *the* defining images of the city.

It's also home territory for Ruairí Quinn, nowadays in a house which looks directly out across that wide expanse of sand or sea. But he's no blow-in here; it's a part of the city that he has lived in, or close to, for practically all of his life. Sydney Parade, Seafort Terrace, Sandymount Road, Railway Cottages, Park Avenue – all locations that have been home to him at some stage in his life before moving to his current house on Strand Road. He still vividly remembers celebrating his sixth birthday in the family home in Sandymount in April 1952.

'We lived just over the railway gates at Sydney Parade,' he says 'and I remember the excitement of living beside the tracks. We wandered freely as kids – there was never any sense then of 'you're not allowed to go there'. Mr Mac ran the shop in the station. We used to put old half-pennies on the line and when they got flattened by the trains they looked just like old pennies.' In the shop, money went much further that way.

From his childhood perspective at the end of Sydney Parade, earliest memories of the strand itself were of 'a big other world opening up, with a view right out onto the sea'. The strand was a place for adventure. 'I remember when Noel Fay across the road made a kayak. I was fascinated with wood-making and I remember the ceremony of it being finished and carried down to the strand for the grand launch – on top of the wheels of an old pram!'

Behind the strand, Sandymount spreads out like a web with its village atmosphere, its local shops and its famous green. All of this is 'special' territory for Ruairí Quinn, and the grid of roads that make up this pocket of Dublin 4 have been well known to him for many years. The green itself also evokes memories and was always, he says, a very safe place for children to play. Only having three gates in or out helped – the escape routes for adventurous toddlers were kept to a minimum. His own children played there when small, and his son Malachi – 'now two metres tall' – still lives in the area and still avails of one of the green's landmarks – Borza's fish and chip shop which, says Ruairí Quinn, has been there 'forever'.

'When I think about Sandymount Green,' he says, 'it's very much a summer image I have,' and yet there's a winter connection as well. For anyone who passes the green at Christmas time will know that the local residents take real pride in lighting it up in keeping with the sumptuousness of the season. 'It's really quite elaborate now,' says Ruairí Quinn. So speaks the man who was instrumental in this local

light show when, as a councillor in the mid-Seventies, he helped raise money to get the tradition off the ground.

The presence of Sandymount Green, says Ruairí Quinn, is central to the village's success. With his architect's hat on he explains that it is perfect in urban design terms – it can be used as a community focus, used for concerts or whatever. 'It's very well utilised,' he says, 'and it shows how a small urban park can be managed.' Sandymount's village atmosphere is further enhanced by its particular location, he explains. 'The main road doesn't run through it, so there's no large volume of traffic – if you go into Sandymount it's because you want to.'

As a child himself, this whole spread of territory, from the strand to the green, was Ruairí Quinn's oyster. 'I went to school up the road in St Michael's, a tiny school at the time. When I was in my second year there, I suppose I was about twelve or thirteen, I became fascinated with maps. I did a big coloured map of the district, just for pleasure and brought it into school. I really knew the whole space of Sandymount very well.'

In his teenage years the 'centre of gravity', as he puts it, shifted somewhat. With friends in Blackrock and Dun Laoghaire, he tended to socialise there, but even at this time in his life Sandymount, the strand and its gateway to far away places, remained a fascination. 'I remember looking out, watching the boats coming and going ... I always loved the idea that there was a whole world out there, beyond the strand.'

The thread continued in his life. 'When I was a teenager, I won the Texaco Art Competition three times and one of my winning entries featured the original twin towers in Sandymount.' With things literary in mind he was also, he says, 'always conscious of the role that Sandymount Strand played in James Joyce's *Portrait of the Artist* and, of course, in *Ulysses'*.

He loves the vista out across the strand, loves the 'sense of separateness' that being out there brings. He tells a story about former British Labour Party leader Neil Kinnock. There he was, this famous Welshman, standing in Ruairí Quinn's house, looking out from the front window across the strand. 'What a city,' he said , 'you can nearly see Wales from here!'

Ruairí Quinn does not see the strand as a private space. 'In the old days, the Number 18 bus came here, all the way from Ballyfermot. For a lot of people it was their only way of getting here to enjoy this place. That's important.' On a fine day in the summer, when the tide is out, he likes to see people actually walking on the sand, not just on the walkway that runs alongside.

He walks there himself, with his wife and young son Conan. It must be bliss for a young boy, that proximity to the sand and the sea, that feeling of freedom. It reminds Ruairí Quinn of how, as a young boy himself, he would imagine that other world beyond the horizon, would wonder about the ships and boats crossing the skyline. With Conan he often plays that same game, remembering all those who have passed across that vista in times past. 'Come and look,' he tells his son, 'come and look and imagine that way, way, out there, you can see the Vikings'.

Ruairí Quinn is the leader of the Labour Party. He worked as an architect, county councillor and senator before being elected Labour TD for Dublin South East in 1977. He has since been Minister for Labour and the Public Service, Minister for Enterprise and Employment and Minister for Finance before becoming party leader in 1997.

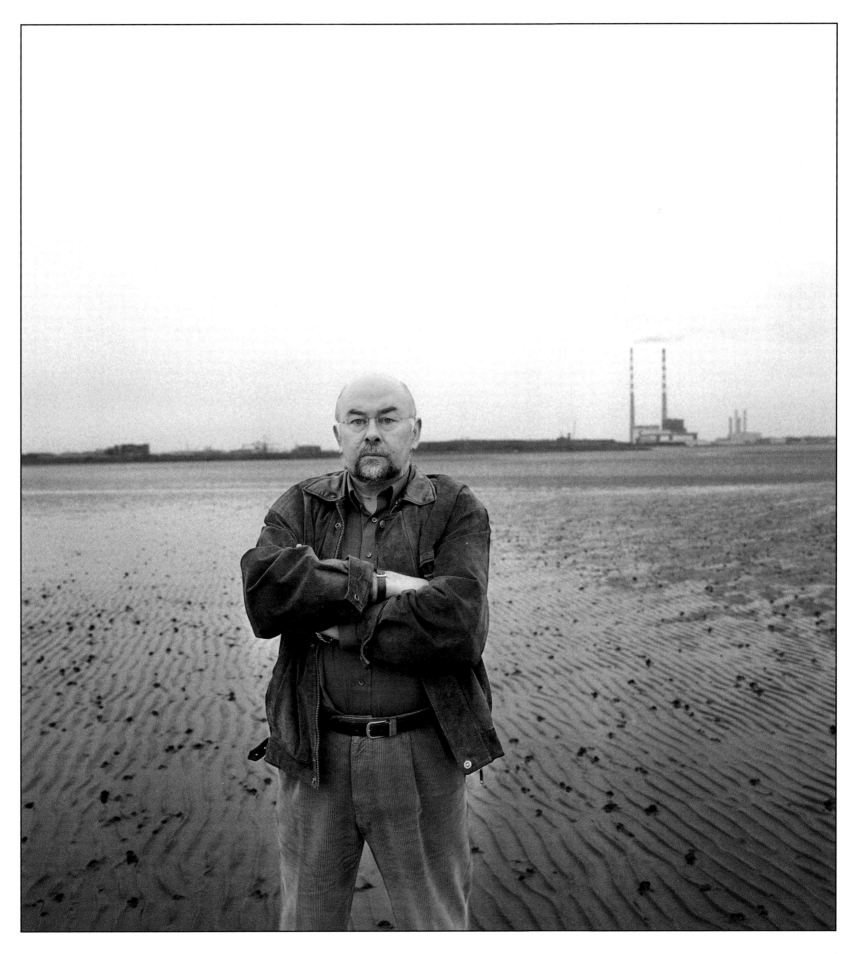

John Minihan

Athy, Co Kildare

It seems somehow appropriate to be wandering around a medieval graveyard with John Minihan. It's a warm, close, midsummer's afternoon and the air is still, the cemetery silent. Ancient metal crosses mingle with more recent headstones; the grass grows high in parts, appears more manicured in others. The yew trees, those old graveyard favourites, add to the atmosphere. It's a bleak yet beautiful picture. Bleak *and* beautiful. Side by side. An image that epitomises John Minihan and his photographic vision.

This burial ground, right on the edge of the Kildare town of Athy is important in his life and two graves in particular have a special significance. One is a family grave in the middle of the cemetery, with the name Mary Collis engraved into the black marble. She died, so the headstone tells you, in 1978. Genealogically speaking, she was John Minihan's aunt but, when you listen to him weave the story of his early life, you realise that Mary Collis RIP was much more than just an aunt. She was his mother figure, the woman who, alongside her husband, raised him after his natural mother upped and left when John was a young child.

The other grave, right down at the back of the graveyard, is also a family plot. No Minihan or Collis names appear here, however, for this is the grave of Kathleen Tyrrell, the Athy woman immortalised in John Minihan's collection of photographs, *Shadows from the Pale*. This photographic essay depicts the small Irish town of Athy over a twenty-five-year period, capturing it in all its many guises. The Katy Tyrell pictures were to set in motion a domino effect, providing John Minihan with photographic access to the writer Samuel Beckett, which in turn would prove a springboard for many other projects. So everything, therefore, sprang from Athy, as John Minihan did himself, more than fifty years ago.

John explains how he was born in Dublin and brought to Athy when he was four-months-old. His real father had died before he was born, and his mother left John in the safekeeping of his aunt and uncle. At the age of eleven he moved with them to London but, he says, 'I never really left Athy.' So he kept returning, arriving in Dublin, catching the train at Heuston station, journeying back to his true home.

'When I was fifteen I joined the *Daily Mail* in London as an assistant photographic printer. So then I was coming home with a camera.' In 1961 he started to photograph people in Athy, the beginning of what, in 1996, was to culminate in his *Shadows* collection. 'When I was at the *Mail* I was looking at lots of books on photojournalism,' he says. 'One book stood out. It was about the North American Indians, by Edward S Curtis. I was haunted by those pictures. That was really the beginning for me ...'

So Athy became his backdrop and its people his characters in a long-running photographic play. It is a town, he points out, with its own literary references. He jokingly quotes from Joyce's *Portrait of the Artist* – 'What part of the body is named after an Irish town?' – and talks eloquently about Patrick Kavanagh's poetry, and his specific reference to the barges from the old malthouse in Athy in his poem, 'Lines Written on a Seat on the Grand Canal, Dublin'.

And now, through John Minihan and his photography, the people of this Kildare town can also stake a claim to a connection with the late, great Sam Beckett. He recalls how his first meeting with the playwright came about.

'Beckett was in London in 1980, staying at the Hyde Park Hotel. I wrote to him. I'd been photographing Athy and I suppose I'd been photographing Beckettian characters without really knowing it. I thought, however, that some of the pictures might appeal to him. He phoned me up and said he'd like to see them. We agreed to meet at nine the next day. I spent a week with him.'

You can see how that set of Katy Tyrell pictures would have had a particular appeal for Beckett, in their bleak and desolate portrayal of death and its aftermath. 'Katy Tyrell was a local woman,' explains John Minihan. 'It was a very cold February morning when I heard that she was dying. For three days and two nights I photographed her, from her death bed to the grave.' The resulting 'Wake of Katy Tyrell' images are central to the Athy collection.

Nowadays John Minihan lives in West Cork but 'every time I leave for Dublin, Athy is a happy diversion for me'. When you witness his reception in the town, there's definitely a touch of the 'local hero' about it. He is keen to stress his roots here, to ensure that you know he is not from a privileged background. He takes you to the house in which he grew up, 13 Plewman's Terrace, now on the wide, main road that heads out of the town, away from Dublin. Yet as John Minihan points out, Dublin is now so close. 'Athy is part of Dublin, it's on the

John Minihan in Doyle's bar (far right); the grave of Katy Tyrell (right); looking out from Doyle's, scene of many of John Minihan's Athy photographs over the years (above)

John Minihan is a photographer. He began his career as an assistant printer with the *Daily Mail* in London when he was fifteen. His *Shadows from the Pale* collection, depicting life in the town of Athy over almost forty years, was published in 1996. He also won acclaim for his pictures of the writer Samuel Beckett and is noted for taking the famous early photograph of Diana Spencer, posing with *that* see-through skirt at the kindergarten where she worked in central London in 1980.

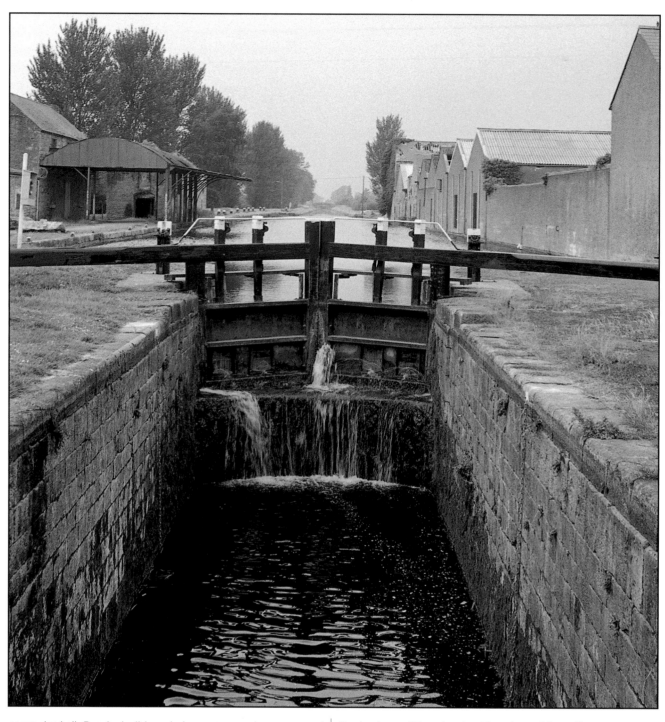

commuter belt. People don't have to leave anymore to prosper, and that's great. On a good day you can leave Athy and be in the bar in the Shelbourne Hotel in an hour!'

One of his favourite places in Athy town is Doyle's bar. 'Bertie Doyle was very important over the years,' he says. 'He was a local historian, the elder statesman of the town. I took many, many pictures in his bar, and have very fond memories of it still.' When he visits the town now, he always stops off at Doyle's, still anxious to meet the local people.

He reminisces about the old days, the sense of community, the sharing. There may be a new prosperity, but John Minihan senses that, in the new Ireland, there is also something of what he calls 'a poverty of spirit' creeping in.

Yet, despite the changes, despite the years away, Athy is still the town that defines him, the place to which he has always come back.

The leaving and the returning. The return of the native.

Back in the graveyard he conveys a real sense of the old days here, before the new-found prosperity, when people left and rarely came back. The railway line runs right alongside the medieval burial ground. 'Just imagine,' he says, 'people came home here to bury loved ones, mothers, fathers ... Then they left to go back to England, or wherever. The final place you see from the train is the graveyard. For so many people that was their last view, their closing memory of this town.' It's a powerful image and a fitting one to draw. Large numbers of people left forever, but John Minihan kept coming back.

'So many of us are displaced,' he says. 'It's nice to have a place to call my own. When I really look at it, Athy has been the launching pad for everything I've done in my life. No matter where I go or what I do, this will always be my town.'

Antony Rudenko

Howth Head, Co Dublin

Antony Rudenko, right out on the edge of his 'magical rock' (far right); Howth Castle (above)

For Antony Rudenko, as a child growing up in Raheny on Dublin's northside, Howth was 'a magical rock in the distance'. And it was the rocks themselves, right up on Howth Head, that held such appeal. Ideal territory for scampering around, clambering up and down the cliffs, in search of birds' eggs. Still knowledgeable about the specifics, the birds' names trip off his tongue like the presenter of a wildlife programme - razor-bills, guillemots and, of course, the herring gulls: 'They were really dangerous, a big adventure, because you'd be hanging out off the cliffs and they would swoop down and really bombard you.'

Of course, Antony Rudenko was not supposed to be there - parental warnings made clear that the rocks were forbidden territory. But for he and his friend Peter, 'Howth became our playground', and they worked out their own method of getting there as often as possible. 'We'd go up to Raheny station and wait in the bushes for the Howth train to come along. We'd have our fare, but we wanted to keep it. When the train pulled in, the guard would step off for a few minutes, and we'd leap from the bushes, jump on and sit on the floor so that we couldn't be seen. We'd get to Howth and fly out the door of the train, still with our fourpences intact!'

The adventures up on the Head brought a few close calls - like the day that Antony thought he was crawling on solid ground high on the rocks, only to discover that it was shingle and that he was slowly but surely slipping off the rock face. 'I was lucky,' he says, 'I was very thin and very light, so I clung on like a spider and I was OK. Even talking about it now, the hair stands up on the back of my neck.' It didn't stop the outings, though, but it did, he says, 'give them a bit of an edge'.

His summer reminiscences of boyhood are almost all basked in sunshine, and yet there's much more to his affiliation with Howth than childish capers.

'Around the time that I was about twelve or thirteen,' he says, 'I became aware that Howth Head has magical qualities. It's a place that is steeped in pre-Christian tradition - there's a dolmen there, behind the castle grounds, and all kinds of symbolism from pagan times. There's a real mixture of romance and adventure - all the mystery of pre-Christianity ... I've always considered Howth to be the halldoor to Ireland.'

A few years later Antony left Howth, and Ireland, behind when, at the age of fifteen, he was selected to study dance and drama at the Arts Educational Trust in London. From there, he was awarded a scholarship to the Royal Ballet, an opportunity that was to lead to a career where he travelled, time and again, across the globe.

Yet he invariably returned to his native country, and in particular to one favourite spot. 'I always came out to Howth, to sit up on the head and think about my work. I really think that there is a special power here, a kind of powerhouse of energy ... it always worked for me anyway.'

He recounts one specific incident. 'I remember that I had hurt my ankle and my teacher, Stanislas Idzikowsky [he of the Diaghilev Ballets Russes and the legendary Nijinsky's best friend] told me to go home and rest it. Of course, I didn't rest it at all because off I went up to Howth Head. And even though I was walking on it, the injury got better much quicker than normal.'

As Antony's career progressed with the Royal Ballet, he took on more major roles and often, before a big performance, he would return to his special place, sit up on the hillside, and work everything out in his head. 'When I couldn't get back home,' he says, 'things never went as well.' When the Hong Kong Ballet asked him to stage *Giselle* for them, he told them that he would first need a week in Ireland. Back he came, and this time he actually booked into a B&B in Howth itself, and spent all his time out there. Then off he went to the East, to *Giselle*, and success.

When Antony Rudenko eventually left the world of dance behind, he found himself living in Mexico for some time, uncertain of exactly what direction his life should take. It was there that he met an old man. 'He was a seer,' he explains, 'and I told him that I didn't know what to do, and do you know what he told me? - "You must climb up to the top of a very high hill and think about your life, everything you've done and everything you want to do." He also explained to me that most people live staid, non-eventful lives. I hadn't - I mean, most of my friends from my Royal Ballet days were dead. I'd always had a sense of danger, even as a child.' The old man wasn't being judgmental, just explaining that, such had been Antony's life, he needed now to take serious stock of it, to reassess, and start again.

He was, Antony Rudenko says, an extraordinary human being, so he took his advice and returned, from Mexico to London, and on to Dublin, and finally Howth, with its high hill and its life-enhancing spirit. And he found what he was looking for - peace, friends and a new direction as an artist. 'Howth is still the first place I come to when I need to think,' he says. 'Up on the head, I sit right out on the edge and look back over Dublin - you can see the whole city spread out and you know that all the people down there are involved in their own joys and their own sorrows. Yet I'm not part of that, I'm separate at that specific moment. It's everything for me - it's yoga, it's total detachment.'

When you look across at Howth from the south and take in the shape of the headland, it's like a woman, says Antony Rudenko, 'a woman lying on her back with her arms across her chest'. The part he loves the best is the woman's head, right out on the edge, with the rocks and the birds, the flora and the fauna. 'It's a microclimate up here,' he says. 'Just look at the rhododendrons ... and the wildlife - the last day I was up here a great big owl flew over, at three o'clock in the afternoon! Something like that always happens here, there's always some moment, some magic, that you bring away with you.'

Antony Rudenko was born on Dublin's East Wall Road and moved to Raheny as a young child. At the age of fifteen he was invited to study dance, drama and music at the Arts Educational Trust in London. He was then awarded the Nanette Du Valois Scholarship to the Royal Ballet School, graduating to the Royal Ballet Company with whom he travelled the world. Now returned to his native Dublin, he has worked on Noel Pearson stage productions and in film. He is also a painter and sculptor.

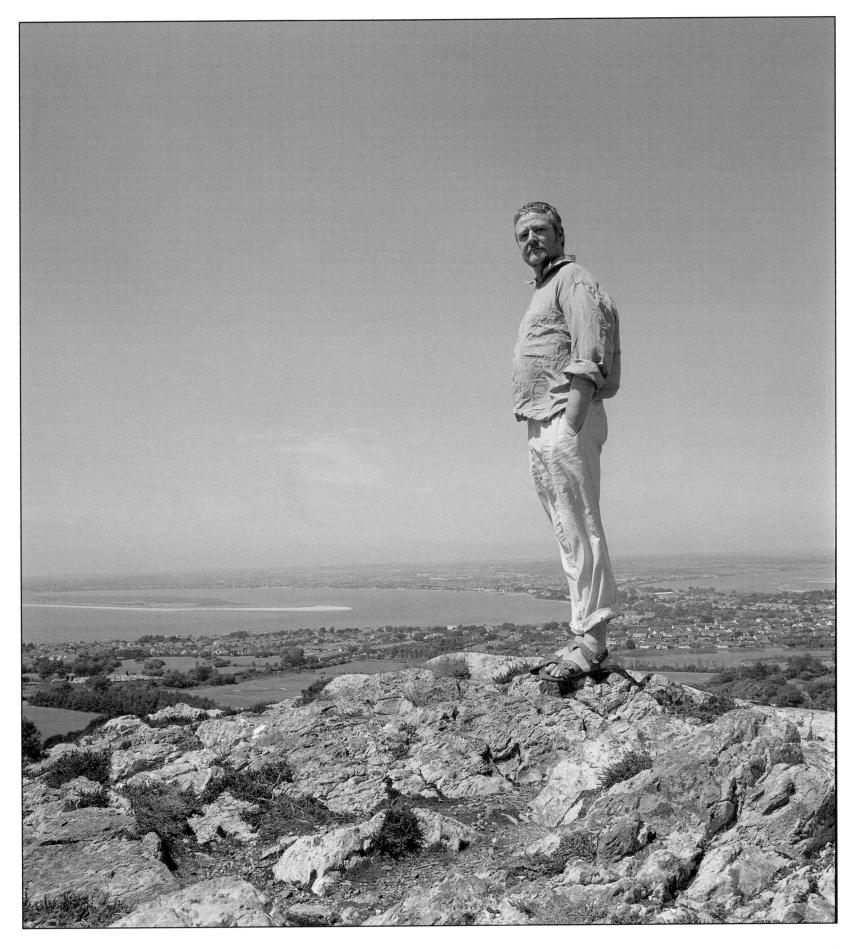

Lorraine Keane

Dun Laoghaire Pier, Co Dublin

Lorraine Keane on the West Pier (far right); harbour moorings (right); the East Pier bandstand (above)

'I'm really a mountain girl,' says Lorraine Keane. 'I grew up in Rathfarnham, at the foot of the Dublin mountains, but as a child my parents would always bring me over to the coast'.

Saturday was *the* day for the Keane family outing. Lorraine's father was a musician and every week the family would venture out en masse, (six girls and one boy), to Dun Laoghaire; first to the shopping centre, then out along the East Pier to the bandstand, where her father used to play. 'We were like the Von Trapp family from *The Sound of Music*,' laughs Lorraine.

So her affiliation with this part of the city started early. Later, when she left the family home and struck out on her own, she moved first to Foxrock, and then to the hinterland of Blackrock. Now, Lorraine is firmly settled, just off the coast road, in Monkstown. 'I was always edging towards the sea,' she says, 'and now I've finally arrived'.

She now understands the pull, the power, of the waves. 'A few years ago I remember a friend of mine from my college days saying that he could never leave Clontarf, that he could never live anywhere but there, by the sea. I remember thinking that that was a ridiculous thing to say. But now, I have to admit, having lived somewhere like this, it would be very difficult to leave. I mean, my little sister comes over from Rathfarnham to stay for the weekend, and when she's leaving she says that she feels like she's been away on her holidays!'

Around ten years ago, Lorraine Keane's aunt bought an apartment in Dun Laoghaire, where she lives for part of her year. Lorraine is particularly close to her, and says there's nothing she likes better than to get up in the morning (her time off from a work point of view), arrange to meet her aunt for a walk, and get out there to 'freshen up and blow the cobwebs away'.

There are two piers in Dun Laoghaire and, although Lorraine's childhood memories revolve around the 'grander' easterly one - situated at the Sandycove end of the town and hosting the aforementioned bandstand - Lorraine actually favours the more unspoilt West Pier, close to Monkstown village.

'I prefer it because, when you're on the top path, you can see the sea on both sides. No matter which way you look, there it is. It has a much rougher surface than the other pier, so it's not ideal for jogging. But I do my power walking here, four or five times a week if I can, and yes, I do go right out to the end.' Work is currently

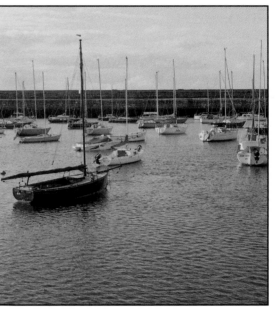

underway on this pier; jetties are being constructed, things are being 'improved', but Lorraine Keane hopes that the natural beauty of the place is not spoiled as a result.

Meanwhile the East Pier, which tends to be busier, is, she says, a great spot for 'Maeve Binchy-style people watching! At any time of the day or night there seem to be people walking there - it's great to be able to wonder about their lives and put them into different scenarios.'

Apart from the pier itself ('a great place to think, to clear your head') and the Dun Laoghaire travels with her aunt, Lorraine Keane appreciates the wider dimension of this section of Dublin's east coast. She absolutely adores the village of Monkstown for its familiarity and friendliness: 'There's a slower pace, it's so much easier to get around, to get things done, than right in the city centre. Don't get me wrong, I'm a Dub through and through, like my parents, my grandparents and my great-grandparents, but I just love the village atmosphere along this stretch of the coast.' Lorraine enthuses about the restaurants and the local shops. Caviston's fish restaurant and delicatessen on the main road in Glasthule is a particular favourite, and O'Toole's the butchers ... her passion for the area is quite specific in its choices. 'Sure you'd really have no need to go into town at all,' she laughs.

But in the end it's the pier that's the place for her and, although she doesn't sail herself, she likes observing the many vessels, large and small, out there on the water. It's not that sailing is a no-no for Lorraine, it's just that she hasn't got around to it yet. She would like to learn about it, she says, 'to have a bit of actual knowledge about the whole thing. They run sailing courses down at the West Pier and it seems to me like a great thing to do.'

Even though she lives fairly close to where the traffic passes en route to or from the ferry terminal in Dun Laoghaire, the volume of that traffic doesn't bother Lorraine Keane. You get the impression, in fact, that she quite likes the two contrasting worlds that proximity to the sea and to Dun Laoghaire provide for her - on the one hand there's a busy thriving community, a place she can be proud of, where people come to visit; on the other hand, there's that quieter world, the one with the self-imposed loneliness of the long-distance walker, out there on the West Pier, taking it all in, blowing the cobwebs away, with the sea rising on both sides and the entrance to the harbour, right out at the end, yet always firmly in her sights.

Lorraine Keane is entertainment editor with TV3. She studied journalism at Senior College, Ballyfermot before going on to work for the Automobile Association as an 'AA Roadwatch' radio traffic presenter. She has also worked in television, on programmes such as *Start Me Up, RPM, Drive!* and *Live At Three*.

Roger O'Reilly

Roger O'Reilly on the banks of the Boyne near Oldbridge (far right); the heart of Drogheda (above)

The Boyne Valley, Co Louth

'If I had to choose somewhere to spread my ashes it would be at Oldbridge, close to the site of the Battle of the Boyne,' says Roger O'Reilly. He is quick to point out that his fondness for this location has nothing to do with either William or James, but rather with his boyhood memories, from a time when this area of the Boyne Valley was his playground.

He's still familiar with all the local landmarks: Silver Bridge, so named after the latticed bridge nearby; another spot referred to as the 'Obelisk', its name derived from the now-absent monument, originally erected to celebrate the victory of William of Orange; and then the river itself. Roger O'Reilly loves the river.

'It's around the Obelisk that the river starts to meander towards the more treacherous waters of the Curly Hole. In other parts it's really quite shallow and tame.'

But Roger spent most of his childhood beside the sea at Bettystown, so what is the appeal of this other form of water?

'Give me a long, meandering river any day rather than the sea,' he explains. 'There's something so relaxing about it, a depth to it ... all those sayings spring to mind - about a river being wise, about life being like a long, slow river ...'

Roger O'Reilly was born in Drogheda and lived in the town itself until he was about five years old, when the family moved out to Bettystown, 'around the corner' as he puts it, 'from the mouth of the Boyne'. In Drogheda town he had lived on Georges Street, 'Gorgeous Street' in the parlance of childhood, close to his parents' restaurant. Even after the move to the coast at Bettystown, his parents kept their business going, so Drogheda and its environs remained Roger's playground much more than the seascape of Bettystown.

His earliest memories revolve around the River Boyne - the fishermen in their long boats with their nets, practically right in the town; other people with air rifles shooting at the mullet in the water off Wellington Quay; and the legendary raft races in the town. 'We all built our own rafts,' says Roger O'Reilly. 'The race started up at Rafferty's, where the tidal bit ends, and we'd row down into the town. People built the craziest things - one year I built a desert island as my raft with an octopus trailing along in the river behind it! It was a great visual event with mad engineering projects. One year there was even a competition to see who could fly across the river and one guy had a go - attached to twelve turkeys!'

The Boyne, he says, 'has a big influence on Drogheda. It's part of the town and part of everyone who lives there.' The town itself went through the doldrums in the Seventies and Eighties but things are changing now, he says. 'For years I had a love/hate relationship with Drogheda. Now I go back often enough to be familiar with the changes. I hate the idea of going back simply to try and recapture the old days.'

Yet the old days are firmly etched in his consciousness - the adventures with friends, the great outdoors, the 'characters', their childhood fixation with nicknames. 'Everybody in Drogheda had a nickname,' he recalls, recounting one funny occasion when this was all too apparent. 'We were just young kids, playing football,' he explains, 'and there was a guy called Snotser Byrne who was a very good player, so we decided to call around to his house to see if he would play on our team.' There were four of them in the visiting delegation, and on arrival, just before ringing the doorbell, they realised they couldn't remember Snotser's real name. 'Eventually, we decided by consensus that his name was Sean, so I rang the bell and his Da, complete with string vest, answered the door. "Is Sean in?" I asked politely. "Hey, Snotser," yelled the Da, "somebody's looking for you".' So 'Dodger' O'Reilly discovered that there was nothing to be gained from etiquette, that a nickname is a nickname is a nickname.

And there were rituals to be adhered to. Like the New Year's Day walk when, as teenagers, every year a gang of friends would journey out from the town and way, way up the river. 'We'd walk out by the ramparts to where the canal begins,' says Roger O'Reilly, 'then on out to the sand traps and further into the valley. There would be about twenty of us. We'd finish off near an old wrecked cottage not far from Oldbridge, where we'd just spend the whole day, hanging out. Then at night we'd head back across the fields, like the Ku Klux Klan on a day out.'

The ancient burial site of Newgrange holds other childhood memories - there was the walk from there to Oldbridge which, he remembers, became virtually impassable in the summer months, due to the overgrowth. So when an outing in that direction was in order, the gang came complete with machetes to hack their way through on their boys'-own, derring-do adventures.

Conscious of how the Boyne divides Drogheda, Roger talks about the upper river, towards Newgrange, and the lower river, meandering towards Mornington.

'I remember standing once on the viaduct in the town, right on the edge, looking down into the coal yard, and out across Drogheda, north towards Baltray and south to Mornington,' he says. 'I used to cycle out towards Mornington - it's a townland that stretches for quite a distance. There's a graveyard out there where a friend of mine is buried. Then, when you get into the mud flats at Mornington, most of it is a bird sanctuary.' The local names there trip off his tongue - Maiden's Tower, Lady's Finger - all with their own air of romance, all part of a landscape that is so evocative for this illustrator.

Yet along this valley, through this stretch of land with so many highlights, it is Oldbridge that keeps drawing Roger O'Reilly back. This is the spot where the ashes are likely to be scattered after all. And he remembers that in his home, when he was a child, there was a painting that used to hang on the wall, an image which he thought of as 'the bendy tree painting'. It always fascinated him. What he did not know as a young boy was that it was painted by a local artist, a woman from Termonfeckin. Nor did he know then that 'the bendy tree' in the painting stands at a particular point on the River Boyne, near a spot that was to become his teenage playground. Just past Oldbridge.

Roger O'Reilly is an illustrator and cartoonist; his work has appeared in newspapers and magazines in Europe and the United States. He is a regular contributor to *The Irish Times* and *The Sunday Tribune* and to various lifestyle and business magazines in Great Britain. His paintings have been exhibited in Switzerland, Ireland, Holland and France, where he is represented in the permanent collection of the Musée d'Histoire Contemporaine in Paris.

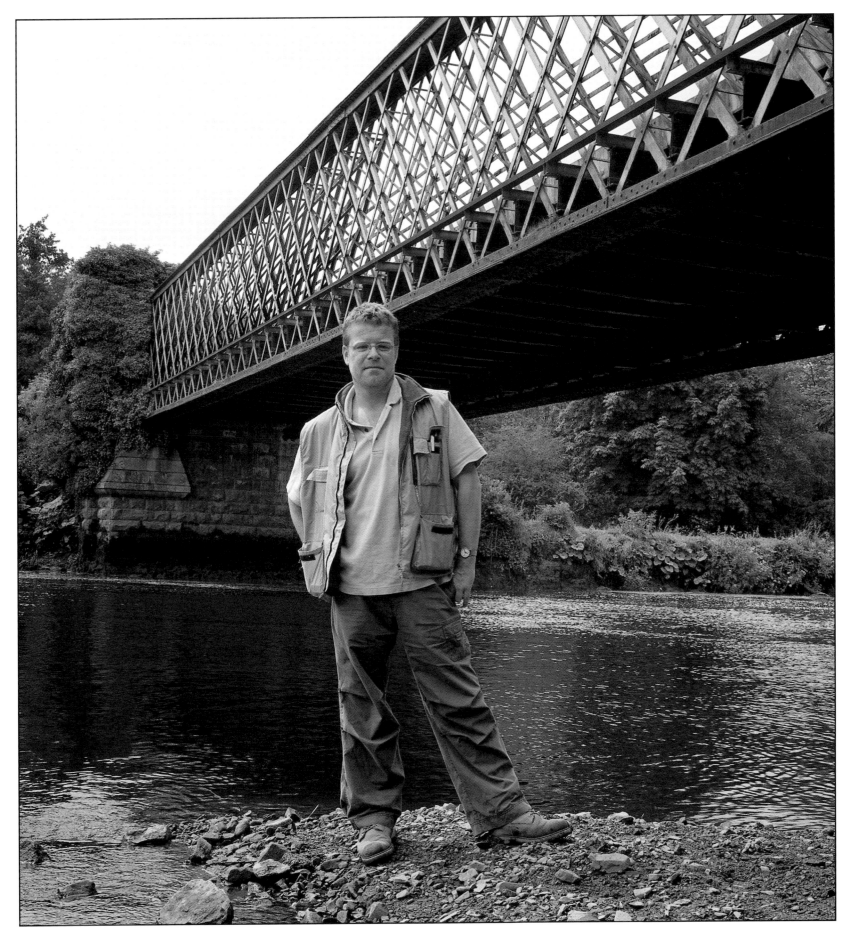

Mick Rafferty

Spencer Dock, Dublin

Mick Rafferty on the bridge above Spencer Dock: 'a sacred place' (far right); the old CIE yard beside the dock itself (above)

Mick Rafferty is a community activist. Born into a Dublin family where, for generations, the men had worked as dockers, he went on to set up Community Technical Aid, an association that provides skills for urban areas undergoing change. He is also involved in Citywide Drugs Crisis Campaign and is chairperson of the Firestation Artists' Studio. At the age of fifty, he hopes to gain recognition as an emerging young poet.

The room was packed to capacity – press, developers, property agents of all shapes and sizes. Grey suits everywhere. It was long before the Celtic Tiger earned its stripes and yet you could almost smell it in the air that day – money. It was a sunny afternoon well over a decade ago, and the property developers and their cavalcade had come to town. To the very heart of Dublin town – to its docklands, to be precise. It was the day that charted the beginning of the development of the famous 'twenty-seven acres' beside the Liffey, the financial services centre area, now well established in the capital's city centre. It was the start of something *big*.

On that afternoon, amid all the self congratulation and the general back-slapping, questions were invited from the assembled throng. The usual things were dealt with – cost of project, what it would involve, when building would commence, how long it would take … Then up stood someone who was not a developer, nor a member of the press contingent. Nor indeed was he wearing a suit, grey or otherwise, but he asked the real questions. What, he wanted to know, about the people? What about the residents of the area that was about to be torn asunder? What about those who lived on Sheriff Street? How were their lives going to be affected? What kinds of guarantees were these people going to be given?

Now, more than ten years on, Mick Rafferty is still asking the same questions, still like a dog with a bone, still looking out for his own. The 'twenty-seven acres', as he insists on calling it, was a battle lost but, with the whole docklands now a prime money-making site, he's still fighting the war. And there's nowhere about which he feels more strongly than Spencer Dock. It is, he says, 'a sacred place'.

Spencer Dock, of course, has been a controversial site, with battles raging between developers and local residents. Lest you think however, that preservation of this dockland site has more to do with politics than with the heart, just don the mantle of childhood for a moment, and listen to Mick Rafferty's memory:

'We lived in Sheriff Street, in the triangle formed by the canal, the river and the railway. I still have a strange memory of myself and the brother, standing at the parapet of Spencer Dock bridge and looking towards the railway, waiting for the 'puffers'. We'd watch them until they disappeared underneath us, then we'd close our eyes and wait to get caught in the puffs of smoke. I can still remember it vividly.'

Spencer Dock and its environs was Mick's childhood stomping-ground. It is still his territory. Walk the cobbled streets with him and you become acutely aware that he knows all the roads, cul de sacs and buildings – both what is there now and what it has replaced. And he knows the people, those who live their lives here in this inner city pocket and want to stay just where they are. Where their parents were and their parents before them.

Mick Rafferty's own father was from the city quays. He had moved out to what Mick describes as 'rural Ballyfermot', and it was from there that the family moved, back into the city centre, when Mick was about ten years of age.

'It was a culture shock,' he remembers. 'In Ballyfermot we lived close to a farm at Greenhills. Out there I lived a childhood attuned to the seasons – chestnut time, robbing orchards for apples, all of that. Childhood was expansive.' From there to the heart of the city, Sheriff Street's Phil Shanahan House, one of the blocks in what were known as 'the flats'. 'We were told never to give our address as Sheriff Street – we lived in "North Wall".'

So why the move?

'My father was a casual docker. That meant that he had to report every day, to come all the way in from Ballyfermot and stand on the "read" to see if he got work or not. My sister had died, she was nine-and-a-half, and my father, I think, just had a longing to move back to the city quays.'

So Mick Rafferty left behind his *'Paddy-Clarke-Ha-Ha-Ha* life', as he calls it, and settled into the ways of the city. It wasn't easy at first. 'I couldn't get used to being confined,' he says. 'Even the fact that it was a flat and not a house was strange – I mean, you slept beside the living room. It was weird.' Other things were weird too. Like not having all his friends anymore. Like moving from the school system of De La Salle into the Christian Brothers. Like having to play with your brother.

'My brother was a year-and-a-half older than me,' he says, 'and we really had to get to know each other. We were thrown together and a lot of the time we gravitated to Spencer Dock, as a place to play and hang out.' At that time, before CIE filled in much of the harbour, the canal was very swimmable and the Rafferty boys would spend a lot of time doing just that, putting themselves through various 'tests' of manliness. These involved diving down to bring up fistfuls of sediment and swimming down to the sunken barge in The Tar Yard. 'It wasn't like Ballyfermot,' he says. 'The narrowness of the environment here meant that you took more risks.'

You get the impression that Mick Rafferty is good at risks. He left school at fourteen and had a series of jobs. By the age of fifteen he had still never read a book. It was a symptom of his environment but that was about to change: 'There was a guy I liked from Coolock. He read all the time and had words that I hadn't got. He was big into politics so I went into the library and took out a book called *The History of Political Thought*. I went around with the book in one pocket and a little dictionary in the other. I did it because, initially, I wanted to outdo the guy, but that book … what it was saying … it changed my life.'

The social and political awakening led Mick Rafferty, throughout the Seventies, deeper and deeper into inner-city activism and local community work. For him, Spencer Dock is central to that personal epiphany and remains a focus for all those who still live in Dublin's North Wall. 'It's a symbol,' he says, 'of what the whole area is about. It's on a rise and from the bridge you can see all around you. You can see Ballymun. You can see it all.'

The adjoining 'twenty-seven acres' Financial Services site (far right); new buildings where the flats, including Phil Shanahan House, once stood (above)

He acknowledges that things are changing in the docklands. 'It's ironic that the rich used to live here. Then when they all moved out the poor occupied the centre of the city. Now the rich are coming back and treating the old communities as if they have no rights ... no rights even to their memories.'

Thomas Moore wrote that memory 'brings the light'. For Mick Rafferty, the light that shines down the years, through his own past, is a sacred one and all the memories that it illuminates are still as sharp as ever - playing in Spencer Dock as a child, working as a 'casual' on the docks himself, remembering the whiff of exotica that the foreign boats and foreign tales - tall or otherwise - inevitably brought. 'There were wild rumours when the banana boats came in

- stories of scorpions or tarantulas being spotted.' Then there were the animals. 'Because Sheriff Street was en route for the cattle market on the North Wall, there would occasionally be a stampede of sheep or cattle. It all added to the air of excitement.'

And now, looking to the future rather than the past, what are Mick Rafferty's hopes for Spencer Dock, for this place that he calls 'sacred'?

'That there will still be a role for the people here, that they will benefit from any change. That there will be no confinement of spirit, that its people will stay rooted, sacredly, in this part of the city that means so much to them.'

And to him.

David Ervine

Victoria Park, Belfast

David Ervine in his childhood 'oasis in a concrete desert' (far right); the swans are still there (above)

David Ervine is the leader of the Progressive Unionist Party. After leaving school at fourteen, he held a series of jobs before becoming involved in the Ulster Volunteer Force, eventually spending five years in the Maze Prison for possessing explosives. He was a central figure in organising the 1994 ceasefire by loyalist paramilitaries and is currently a Northern Assembly member for East Belfast.

David Ervine grew up in the 'I'll-tell-me-Ma-when-I-get-Home' world of East Belfast. In Chamberlain Street, to be more geographically precise. A long, long street that stretches about three hundred yards from one end to the other. As a child there you could get away with nothing. Everybody knew everyone else and even if your mother was lucky enough to have work, as David Ervine's was, there remained the granny factor. 'Every street then had two or three grannies,' he says. 'There was always somebody to witness and tell of your indiscretions. Within each small community there was that degree of control.'

So breaking away was important, freedom was important – and that freedom was to be found a mile away from Chamberlain Street – in Victoria Park.

'It was an oasis in a concrete desert,' says David Ervine. 'Much of this part of Belfast has now changed but when I was a young kid I lived in an area that was just about as far away as a child could walk to Victoria Park. There was no greenery, no open spaces. So we'd take our ball and a big bottle of lemonade and off we'd go on the trek to the park.'

And what a place it was for a child. A vast, green space, with a big pond, swans, places to run wild and hide in. There was a small boathouse where you could hire out rowing boats, and dotted around were several 'islands'. Although swimming was prohibited, this never stopped them and, as David Ervine remembers, 'there was everything there that kids wanted.'

So the park became a haven for this small boy, who was already having a strange childhood. He was the youngest of five, with one brother, Brian, eighteen months his senior, and three further siblings who were much, much older. It was the two-families-in-one syndrome. David's mother was forty-two when he was born. One older brother emigrated to Australia when young David was ten. It was a childhood of separation, of detachment.

'I didn't really fit in,' he remarks. 'When I was about two I fell into a bath of boiling water and I ended up spending a very long time in hospital. When I eventually came home I didn't talk like anyone else. I talked like the doctors and nurses. I was a very polite little boy.'

So he became best friends with another little boy named Louis Scott. Louis was black. Two East Belfast outsiders, playing together in their Tom Sawyer and Huckleberry Finn world where adventure was the name of the game. And there was plenty to be found. Although the park was only a mile away, that was a long distance for a child who would not normally have ventured out further than six streets in any direction. To put it in perspective, David Ervine explains that Hollywood is only six miles from Belfast city centre. Chamberlain Street is on the Hollywood side of Belfast. Yet a family trip to Hollywood, when he was growing up, was a really big day out.

His early outings to the park were with his father, usually on a Sunday. 'My Da took me as a very young kid. He liked a drink and he'd

have taken a brave sup alright but he never took a drink on a Sunday.' Then David ventured there with Louis and, later, with other friends, as he grew up and his circle widened. 'We'd make a detour past the lemonade bottling factory where my mother worked,' he says. 'We'd call up to her and she'd get us some lemonade to take with us. It was all quite innocent. We'd play and swim in the park, act out the latest American war movies, all that manner of thing.'

So Victoria Park was a very big piece in the jigsaw that was his childhood. It fitted in alongside the local streets, the school, the hospital where he spent a large chunk of his early life. It represented the freedom, the carefree days, of a time when there was much restriction and a great deal of worry, typical of a working-class society in the post-war years. He was lucky, he says, because both of his parents had work; his mother in the lemonade factory and his father in the shipyards or in Shortts aircraft factory – wherever his skills as an ironturner brought him home with a wage packet. As a child, though, David Ervine says that he wasn't always aware of the worry. He tells a poignant story about his mother which sums this up.

'She used to go to the Co Quarter,' he says, ' a co-operative store where she'd be able to buys goods and get thirteen-weeks' credit. I can remember her coming home on the bus with the parcel of goods all wrapped up in brown paper. She'd get off the bus one stop early. It was a long time before I understood that she was doing this to go straight to the pawn shop. She'd hand in the goods and get cash, money to keep us going in the meantime.'

For David Ervine his childhood world was small and Victoria Park, once you got there, was vast. It's not the distortion of a child's perception – it is vast, a green oasis in the now not-so-concrete desert of East Belfast. The swans remain in abundance there, the football pitches are tidily kept, the islands, the pond ... they're all intact. The graffiti-clad boathouse has fallen into disuse but, that aside, things are largely as they were forty years ago. Now the park lies within David Ervine's political constituency. 'I still associate in solidly working-class areas,' he says. 'I live in a working-class housing estate on the outskirts of East Belfast.' He doesn't have to tell you – these are his people. And he is theirs. You only have to see how he is acknowledged on the little streets in and around Victoria Park, a 'hello' here and a wave there. You only have to watch the reaction in a local hotel – Would he like more coffee? Can they get him anything else? He practically has to force payment on them.

Back in the park he recalls exactly how they used to walk there, what streets they crossed, how they'd duck down the tunnel to finally get in. Nowadays the traffic whizzes past the park on the busy dual carriageway that runs alongside it, transporting people in a matter of minutes to what was once the day-out destination of Hollywood, or slightly further to the seaside town of Bangor. Or perhaps just up the road to Belfast City Airport from where they will depart to destinations right across the globe. Size is relative now, distance no

Looking from the bridge towards the now-disused boathouse (far right); a family at play in Victoria Park (above)

longer so easily quantifiable. A mile from Chamberlain Street doesn't seem much anymore.

Yet, for a man who has been so instrumental in bringing about change, it is, you sense, Victoria Park's lack of change that so appeals to David Ervine. For if ever there were symbols that speak of a community, of its many generations, they stand testament here in this place. Here, with the yellow cranes of Harland & Wolf rising like giants in the park's hinterland; here, within sight of the floodlights of the Oval, rallying ground for generations of Glentoran supporters who would flock here, week in, week out, to cheer on the local heroes.

It is within this setting that Victoria Park somehow symbolises the old Belfast of David Ervine's past, and all at a time when he is striving so hard to help give this, his city, a real future.

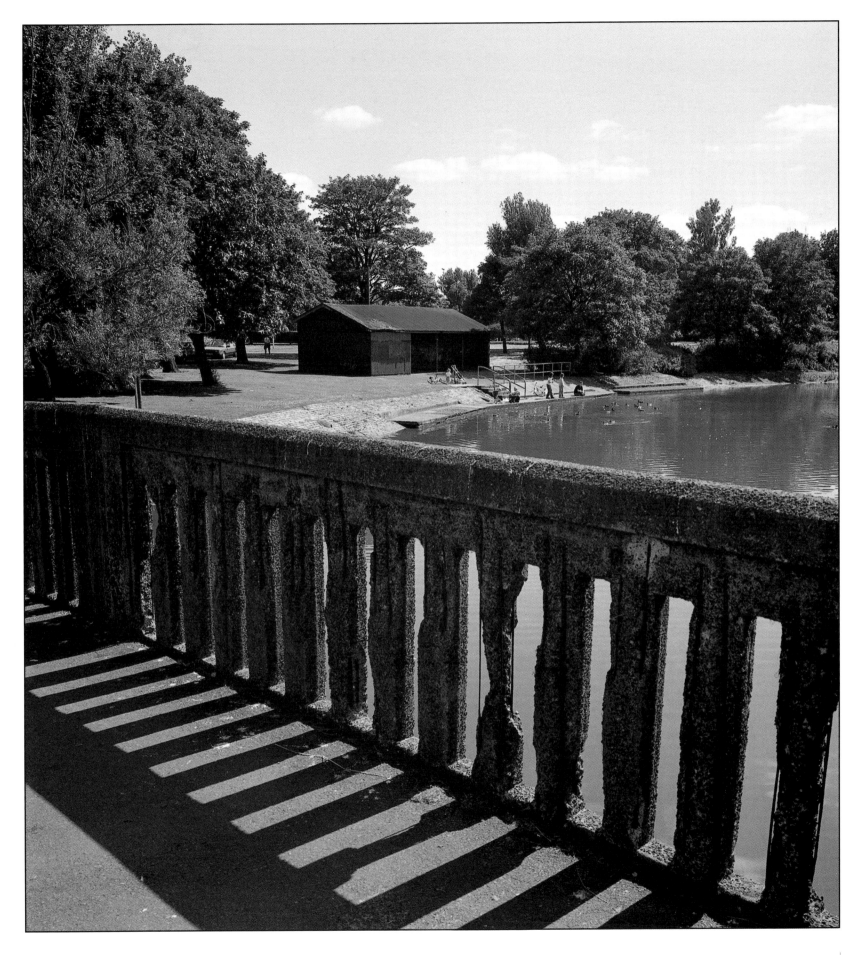

Claudia Carroll

Loreto College, St Stephen's Green, Dublin

Claudia Carroll at the famous 'washing powder' fountain (far right); main entrance to Loreto College (right); the lake in the Green (above)

Her name was Mother Hildegarde and she would have been a brilliant theatrical producer, according to actress Claudia Carroll. Instead she taught in Loreto College on St Stephen's Green and inspired the youngsters there, particularly those who were interested in drama. 'She started me off,' says Claudia, 'and Rosaleen Linehan and Brenda Fricker say the same. Mother Hildegarde absolutely *loved* theatre.'

She was a central figure, therefore, in the world of Claudia Carroll's schooldays, there in Loreto College at Number 53 on the Green. She talks nostalgically about the school and the role it has played in her life: 'I went there from when I was four until the Leaving Cert so both the school and the wider aspect of Stephen's Green was my stomping ground. I only had a teeny garden at home so it was like a huge playground for me and my friends.'

Much fun was had in the park itself, but none perhaps quite so memorable as this incident. It was the last week of term, June 1984, one week before the Leaving Cert commenced. Claudia and Co had been warned to behave themselves, but something of a what-the-hell-sure-we're-out-of-here-anyway attitude prevailed. Round the corner they trooped, from the school to a shop called Donny's, where, says Claudia Carroll, they purchased a box of Persil Automatic. Then it was into the Green, up to the main fountain, and in with the washing powder.

'It was fantastic,' she recalls, 'there were suds everywhere – all over the fountain, over the path, onto the grass ... it was the most beautiful sight, like snow, on a hot June afternoon. It was lunchtime so the Green was packed and there we were, five of us, in our Loreto uniforms, having a suds fight for all to see.'

The girls thought they'd got away with it and arrived, rather smugly, into school the next day, where they were promptly called upon, one by one, to explain themselves. For there, on the front page of *The Irish Times*, was a photograph of the mischief makers for all to see. They were suspended.

Such were the ups and downs of her life there that when Claudia graduated that summer, she imagined she'd left Loreto behind for good. Then came the tragic fire a year later, which killed six of the nuns and destroyed the old part of the school. She talks about that double-tragedy – the deaths of those nuns and the destruction of much of the original character of the famous school, and she recalls the beauty of the place, especially the stunning Wedgwood Room. 'You were only ever brought there when you were in trouble,' she says, 'so I saw it a fair bit!' After the tragedy, Claudia did not foresee any further links with the school, but once again this was not to be.

'After I left college I was teaching drama and then one day, out of the blue, I got a phone call from Mother Hildegarde.' The school's drama teacher, Una Crawford O'Brien, had left (coincidentally, she now acts with Claudia in *Fair City*) and Mother Hildegarde was enquiring as to whether the ex-student would return to Loreto to teach drama. Claudia accepted and back she went, this time into the staff room, to encounter many of the teachers whom she had driven crazy while a pupil there herself. She enjoyed Loreto second-time around and stayed for two years before moving from being a teacher to being a player herself, into mainstream acting.

Claudia loves the stories that fly around about the Green, or the school and its associations. Take Loreto Hall, for example, a building owned by the Loreto nuns on the other side of the Green, right beside Newman House. This is home to some of the nuns and Claudia tells the story that used to do the rounds about this property.

'When Charles Dickens was in Dublin, working as a journalist, he rented a room in the building. It was owned by a spinster woman who lived in rooms right at the top of the house. The story was that she had been due to marry when she was a young woman and had been jilted on her wedding day. She kept one of the rooms in Loreto Hall all set up for the wedding breakfast that never happened. The story goes that it was there, in what is now Loreto Hall, that Dickens got his inspiration for Miss Haversham, his tragic jilted bride in *Great Expectations*.'

You can just imagine the spookiness of that story appealing to the young ladies of Loreto. Yet when they attempted a 'spooky' night themselves during their schooldays it was all a bit of a damp squib. 'One night,' she explains, 'we slept in the Green. We tried to get into the school after dark to camp out there but we couldn't. However we managed to get into the Green itself, and slept there all night. It all sounds wild and a bit scary but actually it was pretty tame in the end!'

Loreto College has been restored, of course, since the fire swept through its rooms fifteen years ago, taking with it a chunk of its history and its inherent character. You get the impression that Claudia mourns the loss of that sense of history. 'You walk through the school now,' she says, 'and it has fire extinguishers along the walls, it's been modernised; it's like a regular school, I suppose.'

Before the fire, you imagine, it was much more than that: a historic building, a place of learning, a house with an incredible front lawn and a cast of characters – from Mother Hildegarde to the naughtiest girl in the school – all of which ensured that life in Loreto was never, ever, dull.

Claudia Carroll is a stage and screen actress who began acting at the age of five. She trained as an accountant but rose to fame playing the part of Nicola Prendergast, whom she describes as 'bossy and a snob' in the RTE soap opera, *Fair City*. She has also acted on stage in productions such as *Lady Windermere's Fan*.

Declan Kiberd

Declan Kiberd on the bridge, amid 'this Utopian space' (far right); the view towards the city (right); the striking structure from the coast road (above)

Bull Island Bridge, Dublin

A wooden bridge. The water glinting through the cracks. A small boy on a tricycle.

These are Declan Kiberd's earliest memories. The bridge is the one that leads from the coast road at Clontarf onto Bull Island. The water is the expanse of Dublin Bay. The boy is himself, aged around three.

'I grew up in Dollymount,' he says, 'and every day my mother took me for a walk to Bull Island. It was the first time we started to go any distance from the house and I remember myself on my tiny blue-and-white tricycle with narrow wheels – the wheels used to get caught in the cracks in the bridge and my mother would have to bend down and help me on my way again.'

He recalls the thrill of looking through the cracks to see if the water was there or not, such being the tidal nature of Dublin Bay: 'When it is in it is really in,' as he puts it, 'and when it is out it is way out.' He drew from that a kind of realisation, he thinks, that the ground beneath his feet might not always be as secure as he imagined it was. It ties in with a wider realisation that things change, nothing remains the same, no matter what our childhood perspective.

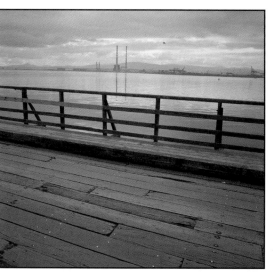

Declan Kiberd's early memories here also include another snapshot in his head, an image of the local anglers casting off the bridge. 'They used to fish for bass,' he says, 'and I'd always make my mother stop so that we could look into the buckets and see how many they had caught so far.'

After his brother was born it wasn't so easy to go on the daily ramblings, and their trips to Bull Island were curtailed for a while. 'I remember missing it at the time,' he says.

Later though, as Declan grew up, he would venture there on his own or with friends, crossing the bridge itself, out on to Dollymount Strand, playing, swimming, enjoying the freedom of it all, the freedom of what he now calls 'this Utopian space'.

He is fascinated by the actual history of the bridge, by its woodenness, by the fact that something originally intended as a temporary structure has lasted for so many years. And by the role played in its construction by none other than Captain Bligh of *Mutiny on the Bounty* fame. Declan Kiberd explains that at the turn of the nineteenth century, in 1801 to be precise, Captain Bligh was commissioned to carry out a survey of Dublin Bay. In his report he recommended the erection of the Bull Wall but his proposal wasn't immediately accepted. Then, in 1819, a timber footbridge was erected on the site of the existing bridge. This eventually disintegrated and then, in 1906, the existing wooden bridge was erected as a short-term structure.

Boards have been replaced, of course, and it is that stop-gap nature of it that also appeals to Declan Kiberd. 'A board rots every month or so,' he says. 'It's a bit like the human body, bits keep having to be replaced. It was supposed to be temporary but it has lasted a century.'

As a child the sense of its precariousness was exciting and he often wondered if it would be swept away completely. 'There's an oddness about it that I like,' he remarks. 'In one way it's very ugly and in another way it is beautiful.'

Bull Island Bridge is essentially a physical structure, but it also has symbolic relevance. Standing in Dublin Bay, it is the first or last view that many people have had of Ireland. It forms a link between the present and the past.

And, for Joycean scholar Declan Kiberd, it has particular resonances which extend the joy he takes from this place beyond the simplicity of a still-vivid childhood memory. 'In Joyce's time,' he says, 'the beach at Dollymount was only one-third of the length it is today.' And the bridge itself? 'In *Portrait of the Artist*, there's a wonderful scene on the bridge when Stephen Dedalus is walking, symbolically, away from Ireland towards the sea. He sees a girl in the water and she is such a vision of beauty and possibility that it becomes a moment of decision.' He quotes this 'Heavenly God' passage from *Portrait*, mentioning how he 'always loved that scene'.

Declan has not always lived near Bull Island, but today he does again and he walks to the bridge practically every day. Sometimes he crosses it and jogs on the beach. Often he stops on the bridge and takes in the sweep of the bay, loving the notion that 'on one side you can see a great city and on the other an area of nature, Howth ... It's an image of a wider world, of things that have disappeared. It is very bound up with my childhood but now that I'm older I feel a need for a connection with the past and the bridge is, of course, a very important one for me.'

In a way, the bridge to Bull Island ties in perfectly with our own island nation view of ourselves. Declan Kiberd confesses himself 'always interested in islands' and sees Bull Island 'as a microcosm of our bigger island – it's both an island and yet not an island.'

In that blurring, it is the bridge itself that remains paramount – temporary yet permanent, leading away yet also leading back, looking towards the city and towards the open sea, constantly offering limitless possibilities.

Declan Kiberd is a lecturer and writer. He won scholarships both to Trinity College and to Oxford University where he achieved a gold medal in his final examinations. His doctorate, *Synge and the Irish Language*, was published in 1979 and his much-acclaimed book, *Inventing Ireland*, in 1996. He joined the English department of University College Dublin in 1979 where he is currently Professor of Anglo-Irish Literature.

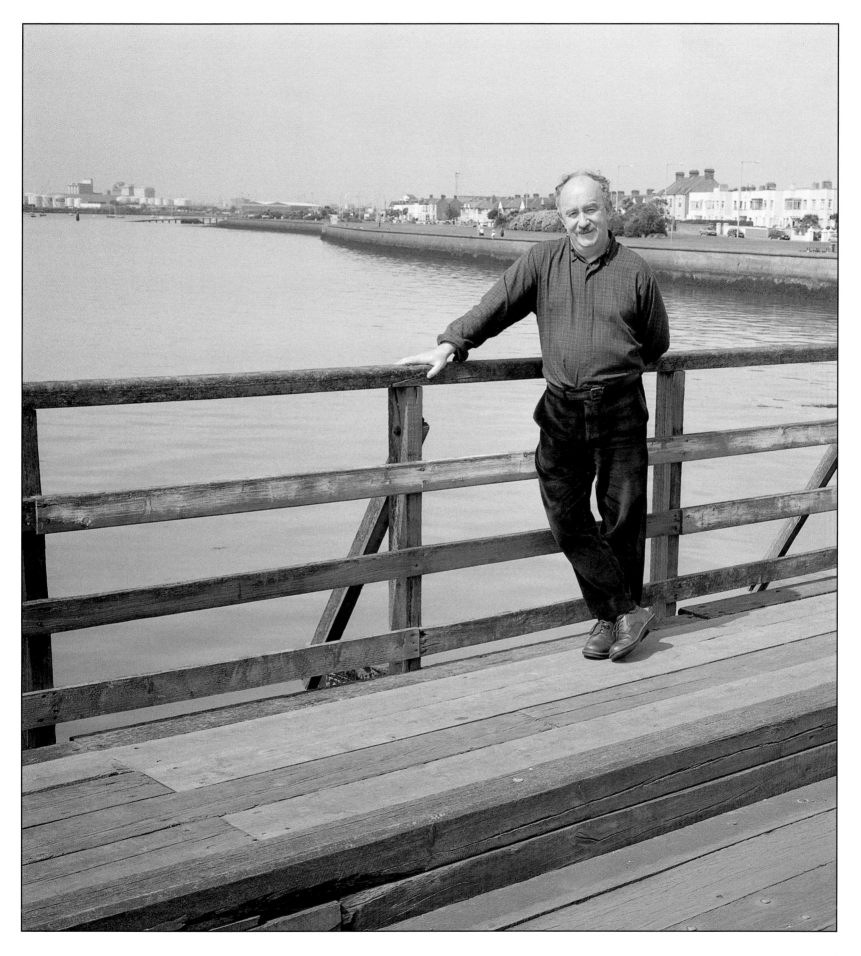

Tanya Airey

Ballinacarrig, Brittas Bay, Co Wicklow

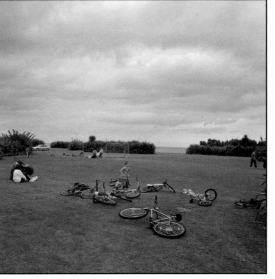

Tanya Airey in 'switch-off' territory (far right); child's play at Ballinacarrig (right); the sweep of the beach (above)

Tanya Airey is managing director of Sunway Travel, the leading Irish-owned tour operator in the country. She entered this family business at the age of seventeen, following a course in travel and tourism with the Irish Travel Agents' Association. From a single shop, she has built the business into a chain which now has seven retail offices, while its corporate arm, Priority Travel, has branches in both Dublin and Cork. She is married to Philip Airey and they have three young children.

Unlike many people from Dublin, Tanya Airey never really went to Brittas Bay as a child. Never did the pack-the-picnic, get-the-swimming-togs, everyone-into-the-car-and-off-to-Brittas-for-the-day routine. It's a place that has more recent associations for her, but ones that you suspect will last into the years to come. It's to do with two things – switching off and children.

There's a curiosity in discovering the kind of place that is important to someone whose business is 'places'. Heading up Sunway Travel as she does, Tanya Airey matches people and places all the time, from family holidays in Spain, to honeymoons in Mauritius to tailor-made safaris in South Africa. She deals in escape and, inevitably, in the course of her business, she has been to some of the most beautiful and exotic destinations in the world. Escape for her, though, and certainly *instant* escape in the summer, is far from the exotic – it's a mobile home, albeit a spacious one, on the Ballinacarrig site at Brittas Bay.

'We bought it in 1995,' she says, 'and as soon as we arrived and saw it we knew it was the one for us.'

It may be one of one-hundred-and-seventy-five such mobile homes dotted around the huge, beautifully maintained Ballinacarrig site, but it surely must have one of the best positions. Perched on the edge of the site, it is truly close to the sea, and one minute takes you down to a little sandy cove or along to the cliff-top from where you can gaze down at the golden beach stretching out below you at Brittas.

'At first when we got the mobile home here, we thought we'd use it at weekends but we didn't really. Now we're here all summer, using it as our base for two months and commuting up and down to Dublin for work every day. Then for two weeks we stay here full-time and totally switch off,' she says.

She loves the relaxed atmosphere life here brings – 'not having to dress up'. When she's working during the week she still feels slightly ridiculous leaving the mobile early in the morning in her 'work' clothes, but it's a small price to pay for having such a laid-back, family-orientated summer.

With her husband, Philip (with whom she works) and three small children, Jamie, Lauren and Max, Ballinacarrig is, she says, 'a home away from home'. They live outdoors. They also eat outdoors, from breakfast through to dinner. And as for the children, they are rarely inside. Their minder in their Dublin home travels to Brittas every day to look after them when Tanya and her husband are working, but such is the activity level in Ballinacarrig that, apart from baby Max, they need very little looking after.

Tanya Airey stresses the safety aspect here. 'Someone always looks out for the children. They never go anywhere alone and if someone does see a child heading on their own towards the beach or wherever they always come and tell the parents. It's so safe for them. It's a wonderful childhood summer.'

She describes the cyclical nature of time spent here, how for lots of families it's where they pass the summer, few ever staying at any other time of year. 'The children all have their friends,' she says. 'They don't see each other from one year to the next, so when they meet up again there is a real shyness at first. Then, before you know it, they're off playing, all the shyness is gone and the relationships are re-established.'

From her own point of view, she says it was a bit strange to leave Ballinacarrig at the end of one summer, no one knowing she was pregnant, and return the next year with a baby a few months old! It's almost like having a double life and yet that is exactly what appeals to her – she can enjoy this life, content in the knowledge that her children are happy and healthy, and yet carry on her work in Dublin at the same time.

So how does she socialise when she's here? Do they go out to eat, go to the local pub, or into Wicklow town which is only a few miles away?

The answer, largely, is no, to all of those questions. 'We stay put most of the time,' she says. 'There's loads of activities organised on the site – Philip and I might play tennis together, or go for a walk on the beach. There's a golf club and if it's warm enough there's the sea for a swim.'

A world within a world. 'It's completely different to my Dublin life. It's so casual,' she says. 'You become very sheltered at Ballinacarrig. I mean, the kids never leave here for the summer. This is their world and life is so small here. Suddenly things that would seem irrelevant in Dublin take on great proportions. Who is in the final of the tennis competition or what time the Under-Eights disco is on is suddenly a big thing. It's funny how priorities change.'

Funny too, how someone who professionally views the world, the *real* world that is, as quite a small place, who inevitably looks at the globe as a series of countries or cities or resorts connected by air miles, can find such contentment herself in a genuinely small world of a few acres, in a mobile home by the sea, overlooking the beach at Brittas Bay.

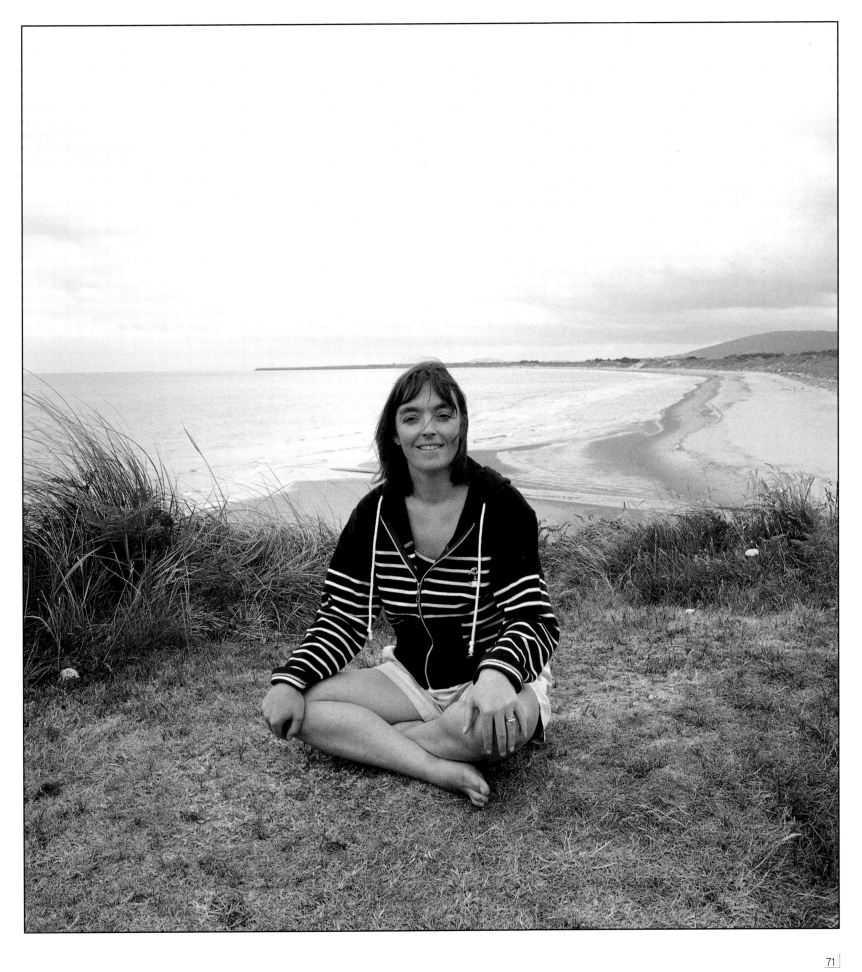

Louise Kennedy

Merrion Square, Dublin

Louise Kennedy, always drawn back to the park which she overlooks from her home (far right); the Sybil Connolly salon at Number 71 (right); 'amazing attention to detail' in the planting (above)

Louise Kennedy is an internationally renowned fashion designer. After attending the College of Marketing and Design in Dublin, she started her own fashion business in 1984. In 1989 she was awarded the *Late Late Show*/Ulster Bank Designer of the Year award. Among her clients are President Mary McAleese, singer Enya and actress Meryl Streep. She has, more recently, forged a relationship with Tipperary Crystal (her home county), collaborating with them on glassware design.

For **Louise Kennedy,** Merrion Square is a many-splendoured place. There is the square itself, composed of exquisite Georgian houses and other fine architecture, with the beautifully maintained park at its heart – a real haven right in the heart of the city. Not populated to anything like the same degree as St Stephen's Green, it is just as uplifting and beautiful in its own understated way. Then there are the artistic aspects, some of which hold a particular resonance for her, from the huge National Gallery edifice whose classical lines dominate the west side of the square, to the modern sculpture of Oscar Wilde in the park, facing out towards the house where the writer lived for some years. And then there is Number 56 Merrion Square, the beautifully restored Georgian building on the square's south side, home to Louise Kennedy.

But Number 56 is much more than a home. From her private apartment where she lives, right at the top of the house, Louise Kennedy's design 'empire' permeates every corner of this building, with her studio, design workshops, and select 'retail' rooms all contained under one roof. From the general to the particular, from the great all-encompassing square to this all-encompassing house, which reflects the varied interests and talents of this Tipperary-born designer, as she continues to leave her mark on the international scene.

Louise has always loved Merrion Square, explaining how it played a part in her life long before her move here three years ago. 'Before I specialised in fashion I did a general art year at college in Dublin and we were regularly sent to Merrion Square to draw. The Georgian details were especially appropriate for pencil drawing so I used to spend a good deal of time here.'

As an art student, the National Gallery was also on the term-time itinerary and, now that it is practically on her doorstep, she still loves to visit, breakfasting in the gallery café when she can. She has a particular passion for the Irish art. 'The Laverys and the Yeats. I've always loved them,' she says, 'and I can't help but be drawn back to them, time after time.' Just as she is drawn back to the park, which she directly overlooks from her home. 'It has always been so well-maintained,' she explains. 'There's still the amazing attention to detail, but to my eye there is a lot more colour in the planting now than used to be the case. This makes it so conducive to walking – people don't really utilise it properly – it's a city park with a wonderful atmosphere. Wander in there and it's a complete change from the city streets.'

Soon after Louise moved into the square, she got to know that expanse of green particularly well. 'A friend gave me a Golden Retriever puppy as a present, so I got to see a lot of the park at seven in the morning!'

Despite the designer's love of Merrion Square and all its attendant parts, she had no specific plans to buy a house there. Then, in 1996, she began looking for what she calls 'a smart headquarters'. With a number of criteria in mind, 'it was light that was most important on my shopping list,' she says. She decided to stick with the Georgian model after a deal on one such dwelling in Ely Place fell through. Soon after she discovered that Number 56 had just come on the market.

'It was September,' she remembers, 'and when I walked in the light came flooding through from the rear to the front. The colours inside were quite dark but the light from the central light-well and staircase was fantastic. Suddenly I was looking at it as more than a business operation – I was looking at this house as my home.'

The building was in fairly good condition and, having secured the property, ('I was so fortunate to get it'), she spent eighteen months having it restored to the highest standards. 'Now,' she says, 'I have no more traffic stress. It's always a calm, relaxed atmosphere – I just come down a flight of stairs to go to work. And I don't get claustrophobic about 'living over the shop'. In fashion you're always working in some way or another, and a lot of mine happens anyway when everyone else has gone home. It's such a nice environment.'

Louise enjoys the proximity to town, loves living at the heart of things. 'I walk out of my front door,' she says, 'and I'm on Grafton Street in five minutes. There are so many places within five minutes in any direction.' She socialises in the Merrion Hotel, just around the corner. Before its incarnation as an hotel, Mornington House, as it was then known, 'was always one of my favourite places – the plasterwork was spectacular'. So she was delighted that the hotel maintained and restored it to such a high degree. 'With all the Irish art on the walls,' she says, 'it's a place I like to relax in.' And, of course, a two-minute stroll takes her home.

It's strange to think that a two-minute stroll from Mornington House also took Sybil Connolly home. For that doyenne of the Irish fashion industry also lived and worked on Merrion Square, in her salon at Number 71, just a few doors from Louise Kennedy's. It is a connection that's not lost on Louise. She greatly admires the late Sybil Connolly, talks about her 'vision' in being able to combine home

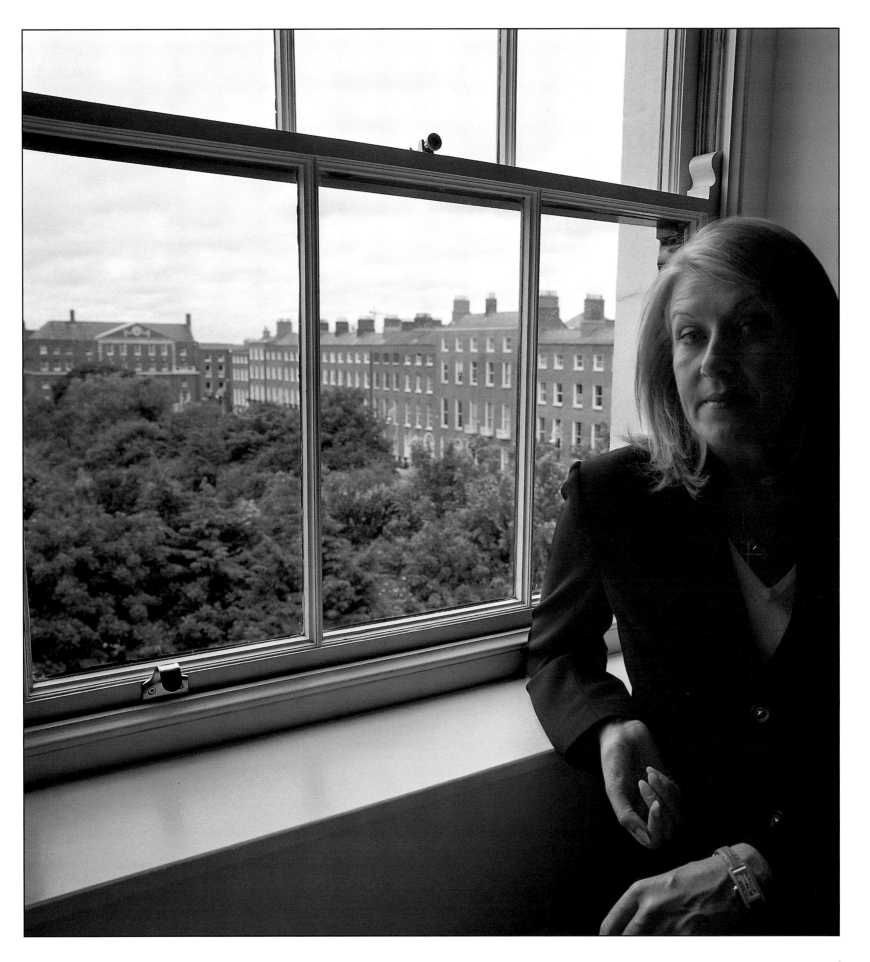

The terracotta monks: 'people are really drawn to them' (far right); the Georgian streetscape from the park (right)

and salon and acknowledges that she was a great 'marketeer'. 'That house has always intrigued me,' says Louise, 'the scale and proportions of the building, the three bay windows ... and of course, I'm aware that she had a fantastic garden.'

While the Connolly garden is indeed famous for its serenity, Louise Kennedy has managed to achieve that same feeling within rather than without. It's to do with the amazing light, and yet it is more than just the light; still you can't quite pin it down. Is it the sense of artistic perfection that pervades the house? Is it the view out over the park? Or the vista from her apartment – Dublin Bay in one direction and the mountains in another? Maybe it's all of those things but, when you hear Louise Kennedy's story about the stone monks in her hallway, you can't help but feel that they have something to do with it.

It goes like this. Louise was travelling abroad on business while the Merrion Square house was undergoing work. It was nowhere near ready for habitation, and she was having trouble seeing the light at the end of the tunnel in relation to the project. It was Christmas and she was in Thailand.

'I was in a huge antique centre, actually going up an escalator, when I saw them. One, two, three, four, five ...' She strained to count how many, as the escalator carried her away from them. A collection of almost life-sized stone terracotta monks.

'I just felt something very strong about them,' she says. 'The touch, the colour ... I knew the moment I saw them that they had to come back here.' Now they stand sentinel in the hallway of Number 56, somehow setting the tone of the place. 'People are really drawn to them,' she says. 'It's something to do with the karma, the sense of history here.'

History certainly threw up one surprise for Louise Kennedy after she'd bought the house. Whilst well aware of the Sybil Connolly connection and, one imagines, with the inevitable comparisons to follow, she did not know of another, more bizarre coincidence that lay in wait closer to home.

'I'd been going through the deeds,' she explains, 'and when I was putting them back in a box I noticed a photograph of the house. When you looked really closely you could see two mannequins.' She discovered that the house, *her* house, had previously been the salon of the Dublin couturier, and celebrated costumier for the Abbey Theatre, Raymond Kenna, famous in the Fifties and Sixties.

Maybe it *is* more than that amazing light. Maybe it's the karma after all ...

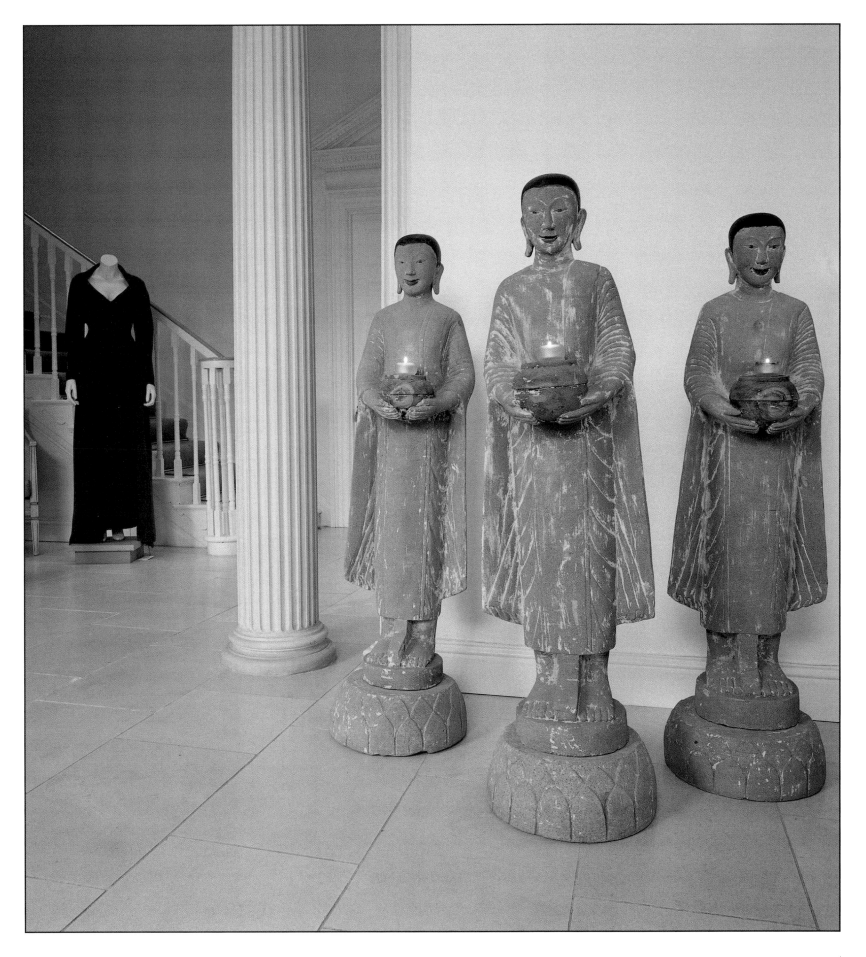

Wallace Dinsmore

The Antrim Coast

Wallace Dinsmore in escape-and-freedom territory at the Giant's Causeway (far right); on the edge of the Atlantic in Portballintrae (above)

Dr Wallace Dinsmore was born in Co Antrim in 1954 and is a consultant physician at Belfast's Royal Victoria Hospital, where he specialises in sexual infection and impotence. He was extensively involved in the preliminary development of Viagra and is currently editor of *The International Journal of STD and AIDS*. A Fellow of the Royal College of Surgeons of Ireland, London and Edinburgh, he has published widely and lectures all over the world. Married to Margaret-Ann Dinsmore QC, they have one son, Andrew.

Late January. Early morning. The edge of the Atlantic. The sea is mountainous and the wind so strong that you can barely keep your balance. Standing on a crop of rocks on the edge of a bay you watch as the waves thunder towards the shore with a deafening roar, sweeping all before them and churning up the water so that it performs its own miracle, turning not into wine, but milk. In its wake floats a wispy white frothiness, like sheep's wool left behind in the rush for escape and freedom.

And make no bones about it – this is serious escape-and-freedom territory, here on the wild, dramatic coast of Antrim, in this bay close to the little-known village of Portballintrae, lying in the shadow of its world-famous neighbour, the Giant's Causeway.

And it is to escape that Wallace Dinsmore comes here, away from the daily pressures of his Belfast medical consultancy and the merry-go-round of international travel that make up his professional life.

'It's a different world to Belfast,' he says. 'No work comes here with me.' Yet the mind still ticks over. 'It's a place to think, a place where you see things that you haven't seen before. The isolation triggers things. There are only a few places where you're ever able to formulate ideas that are actually any good and this is one of them.'

This part of Co Antrim, running west from the seaside town of Ballycastle right round to the historical Dunluce Castle close to Portrush, takes in a great sweep of the coast. Some of the names are legendary – the Giant's Causeway, Bushmills, the Carrick-a-Rede Rope Bridge – and some places are simply quietly impressive – Portballintrae, Runkerry, Ballintoy Harbour, White Park Bay ... It's a coastline with which Wallace Dinsmore has had a long-standing love affair.

He tells an evocative story about how, as a country boy growing up on a farm at Loughguile, not far from Ballymoney, he experienced his first coastal awakening. 'When I was a young child I had asthma and that meant frequent visits to the doctor's surgery in Ballymoney. I'd never seen the Giant's Causeway. I'm not even sure if I'd ever heard of it before then, but all around the waiting room walls were pictures of the Causeway. Those images fascinated me and still, all these years later, seeing the Giant's Causeway takes me back to that surgery and to that particular time.'

Farm life intensified the lure of the sea. Despite the rural upbringing on the edge of the Antrim Hills, the sea was only twelve miles away at Ballycastle, and the trip there and back often constituted the traditional Sunday afternoon drive for Wallace, his parents and siblings. He remembers fondly (as does anyone who knew this part of the world in the 1960s) the 'great ice-cream shop' in that town, famous for its annual 'Oul Lamass Fair. From there the family would drive west, along the very stretch of coastline now so significant to Wallace Dinsmore's life, right round beyond Portrush and into the genteel seaside town of Portstewart, officially over the border into Co Derry, but happy to bask in the reflected glory of its Antrim neighbour.

Portstewart featured again, later in his life, when he met Margaret-Ann, his wife. She grew up in nearby Coleraine and there were many walks together, in their late teens and early twenties. They would stroll along Burnside beach, the stunning stretch of sand that runs to the west of the town, reaching enticingly towards Castlerock and Downhill but cut short by the River Bann, as it thunders out over the barmouth into the Atlantic Ocean and divides the golden flow of sand between the two beaches.

It is territory that Wallace Dinsmore loves and now he owns an elegant home on the edge of the ocean at Runkerry, a little-known spot close to Portballintrae. It is a breathtakingly beautiful, untamed and unspoilt place. One side effect of the Troubles, he says, is that many parts of the North have remained underdeveloped, preserved. There's certainly no 'tack' factor here in this isolated, sandstone house at Runkerry, originally the home of Lord McNaghten who had it built in 1863. With unparalleled views across Blackrock Strand towards the mouth of the River Bush, the house was converted into a number of understated yet stunning holiday homes a couple of years ago. It is to this home, with a huge drawing room window that looks directly out on the ocean, that Wallace Dinsmore retreats with his wife and son for the much needed rest and recreation.

Apart from the childhood jaunts around the coast, he deepened his affinity with this coastline in later years when he became more familiar with the hamlet of Portballintrae, the golden, interminable stretch of sand at White Park Bay, and the many coves and crannies around the Giant's Causeway. More than a decade ago he and his wife bought an apartment in Portballintrae itself. Just a small village on this coastline, it became briefly famous in the 1970s when the Belgian diving crew, who eventually found the wreck of the Spanish Armada's *Girona* just off the coastline, made it their base, departing every day from its tiny harbour in search of Spanish treasure. The Dinsmores' was one of the first holiday apartments to be built on this coast and, like their Runkerry holiday home, it has a sea view.

Now, when he comes to get away from it all to the house at Runkerry, Wallace is virtually surrounded by the sea. The Giant's Causeway is within walking distance and still holds a fascination for him, evoking childhood memories of tales of Finn MacCool. But it is also, as he points out, a World National Heritage Site. 'It's like the Grand Canyon, Niagara Falls ... We're really very lucky to have it here in Ireland. I was out this morning, smack in the middle of winter, with gale-force winds and an appalling weather forecast of worse to come. And up at the Causeway, guess what? There were loads of Japanese tourists clambering up, trying to see as much as they could of this beautiful place.'

So do the tourists bother him?

'Not at all. I don't own it. It's here for everybody to enjoy and I do have my own little bit at Runkerry where isolation and privacy prevail.'

Then he's off on the history of the original house at Runkerry, obviously a subject of great interest to him. He loves the idea that

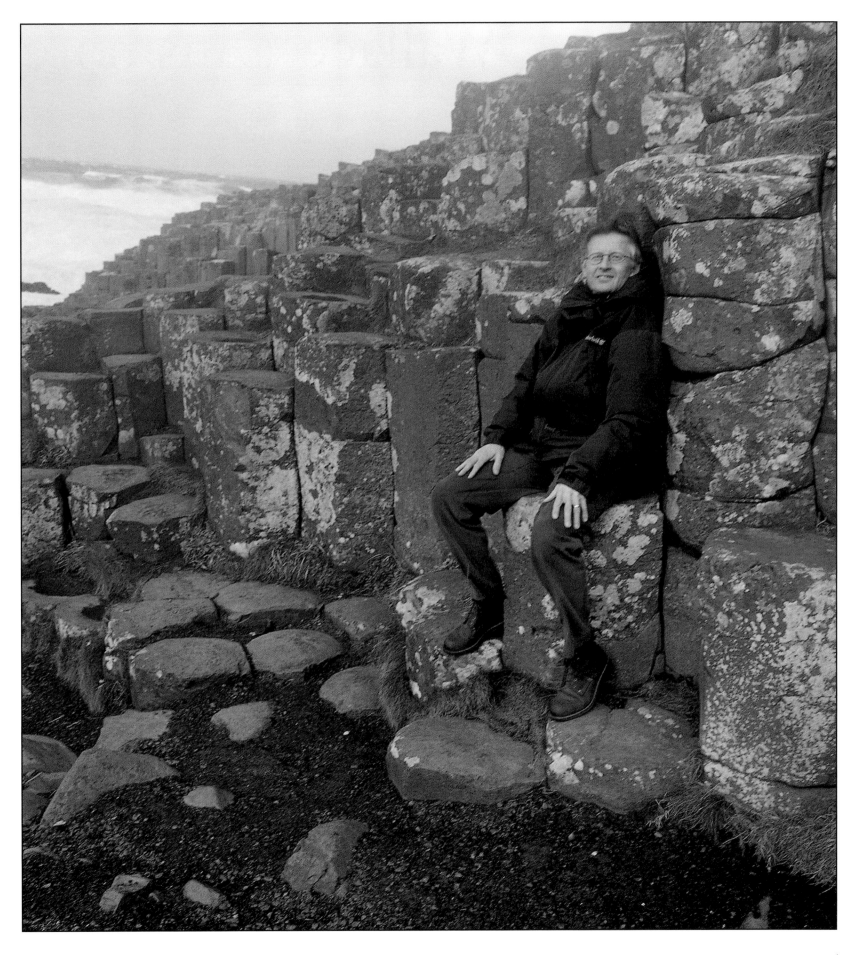

Sunset off the rocks at Runkerry (far right); the ruins of Dunluce Castle, near Portrush (right)

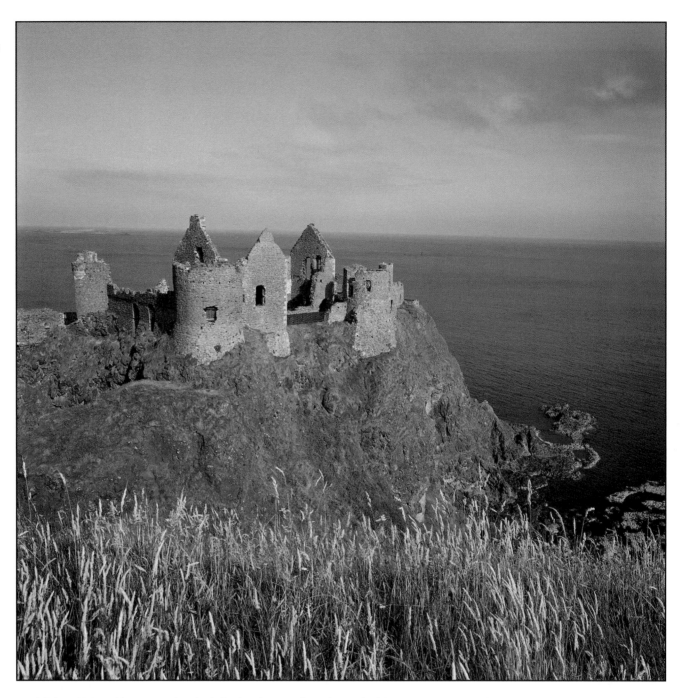

Lord Edward McNaghten was a law lord, the legal connection of particular interest as his wife is a senior legal figure in Northern Ireland. They keep a bound copy of McNaghten's legal judgements in their coastal home. More than a century later, it's a kind of homecoming.

When the house was given to the State in the early 1950s it was first used as a home for the elderly and infirm, before becoming a weekend home for delinquent boys from Belfast. 'The story goes,' explains Wallace, 'that the wardens used to take these city boys out to sleep in a cave for their first night at Runkerry. They were terrified. Then, much to the boys' relief, they would bring them into the house for the second night. Just when they were beginning to feel safe again, they would start to tell them ghost stories about the house. The boys really couldn't win!'

Apart from walking the beaches, fishing off 'The Black Rock' right in front of the drawing room window at Runkerry and playing golf with his young son on the local course at Bushfoot ('I'm the world's worst golfer but it's the closest thing I can find to having a hobby'), Wallace Dinsmore simply enjoys the escape that this coastline allows him.

'We'll always have our house here,' he says. 'It's the most ridiculous luxury that I have in my life - it's objectively ludicrous to have a home that you only spend a small number of days in the year in. But we relax here, we entertain good friends here - and it really is such a privilege to have all this sweep of coastline on our doorstep. If I had my choice to go anywhere, I'd still come here. Once you've done the circuit of airports and hotel bedrooms like I have, there's a huge attraction to coming to somewhere where there's no change of time zone and no passport required. When you travel and see for yourself the great sights around the world, you realise that right here, this stretch of Antrim coastline, is as good as any of them'.

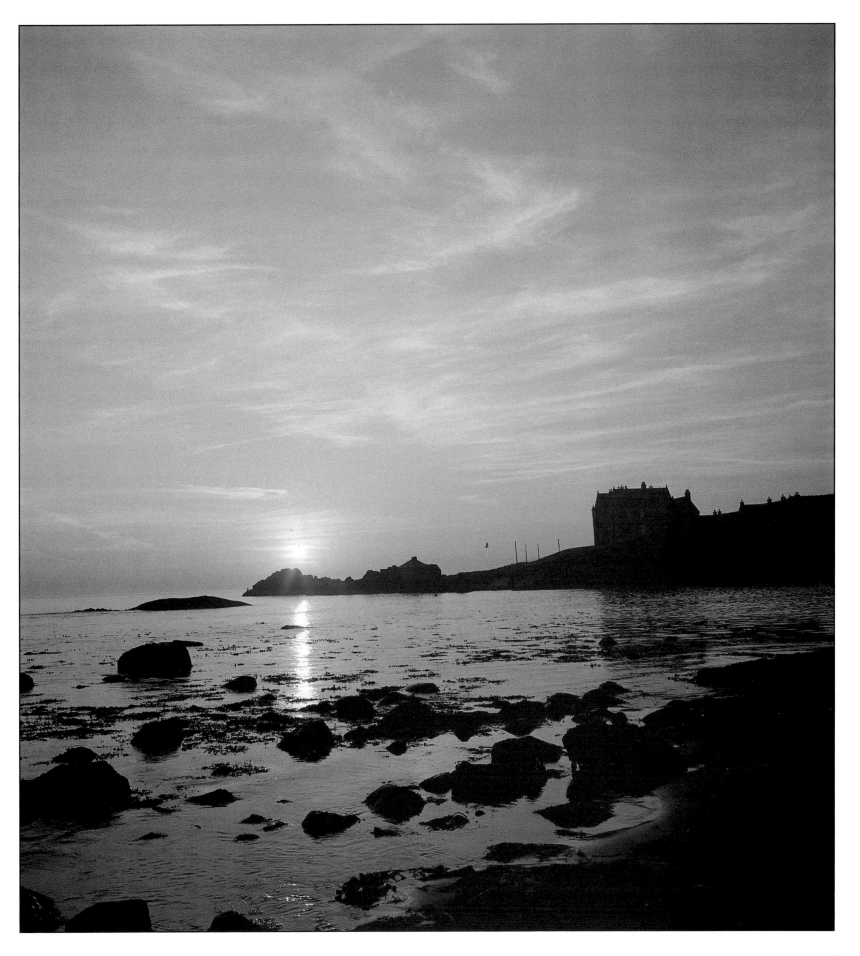

Ivana Bacik

Front Square, Trinity College, Dublin

Ivana Bacik on hallowed ground (far right); the expanse of Front Square (right); that potent Trinity symbol, the Campanile (above)

When you walk into Trinity College, through the front gate on the sweep of College Green, it is like entering another world. Outside the gate, only a stone's throw away, lie banks, building societies, cafés and shops – all the trappings of 21st-century commercialism. Step through, walk along the darkened entrance porch and out into the splendour of Front Square, and there's no escaping the sense of history, the majesty, that pervades this place.

Ivana Bacik is acutely aware of this tale of two worlds. In her role as Reid Professor of Criminal Law here, she works amid the beauty of this environment, passes through the entrance gate on a daily basis, walks across Front Square through the famous Campanile, enjoys the swathes of greenery within the grounds. Often, however, she returns here from the Four Courts, where she practises as a barrister specialising in criminal defence work, a part of her job which shows her, as she puts it, 'the other side of life'. It's a very different world from that of academia and Trinity College, a world, she says, 'of drug addiction and of poverty'. You sense, as she talks, that both aspects of her working life are very important to her, and that Trinity provides something of a haven – albeit it with an attached ambivalence.

A teacher here now, Ivana Bacik loves the college in general, and Front Square in particular. Imagine, though, a not-so-self-assured seventeen-year-old student, a scholarship girl, entering that famous square for the first time back in 1985.

'I walked in on my first day, it was Freshers' Week, and there were all these stalls everywhere. Everybody was interested in you and it really was very exciting.'

Was she at all overawed by the place?

'Yes, in that even then I was very aware of a sense of history, of that notion of successive generations passing through here.' And whatever about the history, she loved the new-found sense of freedom, found it broadening, uplifting, truly educational. 'I didn't like school at all,' she says, 'because I found it so constraining, so very narrow. So college was a real eye-opener for me.'

She describes in detail the geography of Front Square, or Parliament Square, as it is formally titled. She enthuses about the chapel, on the left as you walk from the front gates, about the examinations hall on the right ('not the place that gives students their happiest memories!') and, further along on the left, the social hub of the college, the dining hall and the Buttery, essentially the main campus bar.

Dominating this square is the Campanile, that arched tower

designed in 1852 by Charles Lanyon to house the two college bells, and one of the most potent symbols of Trinity College. But for Ivana Bacik, it is the houses on the left, in particular Number 6 and Number 10, that have particularly vibrant associations. When she was President of the Student Union here in 1989/1990, she worked in Number 6 – Mandela House – and lived in Number 10. She moved between one and the other on a daily basis, work and play both concentrated in Front Square.

'I know that it's only a square,' she says, 'but it is of huge political significance, because it has always been a meeting place, a site for student protests. We used to address rallies here from the dining hall steps – a terrific vantage point ... I don't know exactly how true it is, but apparently UCD, which was built in the Sixties, was designed to avoid giving a platform to radicalism. When you look at it, there is actually no real meeting point at all there. On the most obvious spot there's a pond!'

1989/1990 was a very active year for the student President. It was, she says, the SPUC year, when the Students' Union was taken to court and threatened with jail, until Mary Robinson intervened in her legal capacity to defend the students, setting a precedent in law at the European level. During those difficult days, Front Square, both as a rallying ground and as the centre of operations in Mandela House, was centre stage in Ivana Bacik's life.

There was also, of course, the social aspect that came with living here. In top-floor rooms, with antiquated, shared bathroom facilities, and a view right along Westmoreland Street, Ivana says 'we became famous for our parties'. And then there was the rivalry between the 'Pav' crowd – those who socialised in the Pavilion bar, with its sporting associations - and the Buttery crowd – right at the heart of the action on Front Square. Ivana Bacik was firmly in the latter camp and that bar was her bolthole – dressed in black, listening to bands, a die-hard member of the Buttery brigade.

Come the summer and Trinity Ball time, Front Square took on another guise, and continues to do so, according to Ivana. 'My first impressions were quite magical. You walked in through the tunnel and came out into the square and suddenly there it was, all lit up, swarming with people, really enchanting.'

Transformed, from radical rallying ground to relaxed social venue, from classical, historic square to modern outdoor nightclub. Another tale of two worlds, like that of the teenage scholarship girl and the eminent law professor for whom Front Square will always be hallowed ground.

Ivana Bacik is Reid Professor of Criminal Law at Trinity College Dublin. She is a graduate of that university (and a former president of its Student Union) and of the London School of Economics. In her role as professor she teaches criminal law, criminology and the feminist theory of law. She is also a practising barrister and has been editor of the *Irish Criminal Law Journal.*

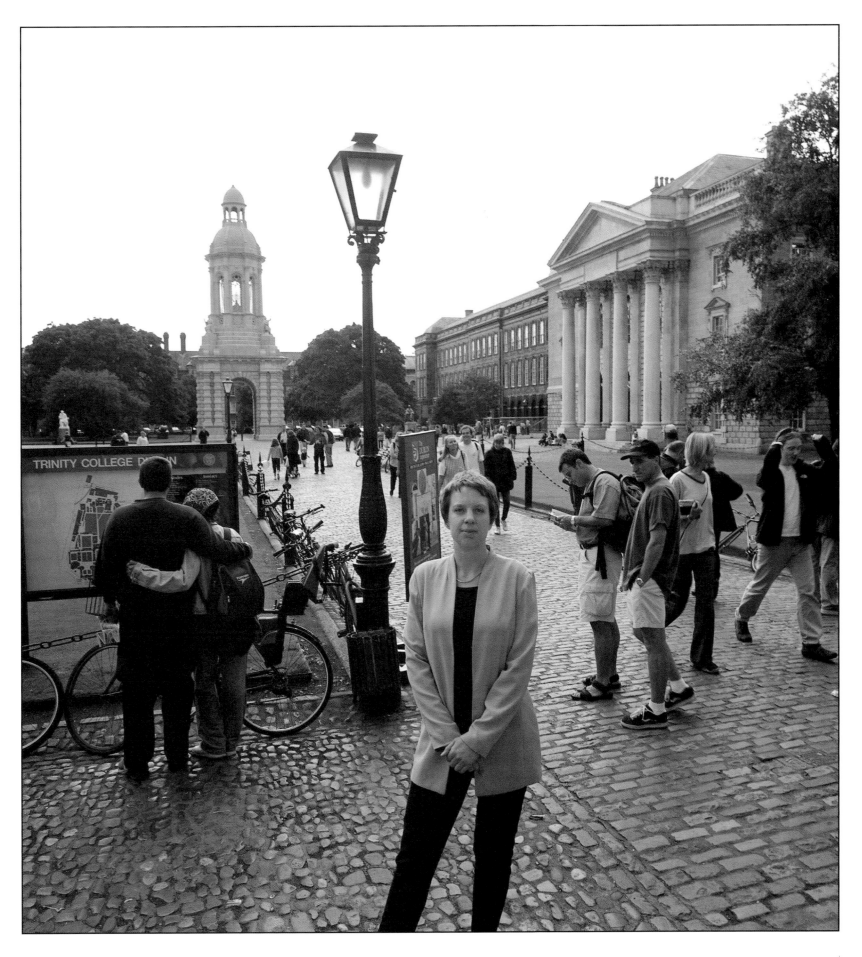

Fran Rooney

The Phoenix Park, Dublin

Fran Rooney at the Wellington Monument (far right); the Papal Cross in Phoenix Park (above)

For Fran Rooney, the Phoenix Park means many things – childhood playground, adult sports training ground, family picnic spot, wedding reception venue – the list goes on and on. These days he lives just beside the Castleknock Gate and drives through the park each day, to the new Baltimore Technologies headquarters just beside the Parkgate Street entrance. Phoenix Park is his avenue, his link from home to work, work to home.

The connection began in his boyhood when, as a youngster growing up in Cabra, Fran Rooney and his pals used the park as their playground. Strange as it may seem, they were especially fond of the polo grounds. It wasn't that this gang of eleven-year-olds had any particular interest in the beautiful game of man and horse moving in perfect symmetry. No, it was to do with the immaculate quality of the turf there – it was a terrific place for playing football.

'The *real* soccer pitches,' remembers Fran Rooney, 'were very badly churned up, as if a herd of cattle had been running around on them. And when it rained, the 'craters' all became flooded, so we used to play on the polo grounds.' Naturally, this was not allowed – 'Occasionally we were moved on but generally we got away with it.' Until summer came, that was, and the polo players arrived in force to claim back their territory for the weekend matches. 'We thought that was a dreadful imposition,' laughs Fran Rooney. 'It was a kind of we-were-here-first attitude.'

One day, he recalls, they were moved on from the polo grounds, only to discover the joy of playing soccer on the cricket pitch. Oh, the thrill of it – jumpers and bags carefully arranged as goal posts on the sacred turf – 'It was like playing at Wembley,' he says.

The soccer thread was to continue in his life and when, some years later, he played League of Ireland soccer for Shamrock Rovers, he continued to use the Phoenix Park as a training ground, particularly for what he calls 'stamina training'. In this context, Fran refers in particular to the Wellington Monument, with its many steps around the base providing an excellent spot for intensive fitness training. Like this monument – dedicated to Arthur Wellesley, Duke of Wellington, MP for Meath and victor at Waterloo – other historic sites, such as the Magazine Fort, now a ruin on a hill, also proved valuable exercise terrain. Indeed, the perimeter of the park itself was put to use, as Fran's ten-mile jogging circuit.

The sporting theme was set to continue here. When, in 1986, Fran Rooney took on the job as manager of the Irish women's soccer team, Phoenix Park was where they also trained.

Yet it is not just sport that makes this place special to him. He is fascinated by the park's history, and also very knowledgeable about its geography – he knows the layout like the back of his hand, and insists on using the correct names for all the avenues that run through it. What you or I might refer to as the main road through the park, he calls Chesterfield Road. He alludes to the aforementioned Magazine Fort, to Ashtown Castle and its museum, to the Eagle Monument, 'in the centre of Chesterfield Road. For many years it was on the right as you drove towards Castleknock, but now it's back in the middle again.' He even has an explanation for the Phoenix title: 'It comes from the Gaelic *fionn uisce,* meaning 'clear water', because the Liffey is flowing close by,' he explains.

On the controversial issue of the zoo, also housed here, he believes that things are definitely improving, and that the new 'African Plains' project, instigated this summer in a move that will actually double the zoo's overall acreage, is a long-awaited plus factor. As a kid, his memories are not of actually visiting the zoo, but of 'finding lots of different vantage points outside, from where we could view the animals. We'd be on our way to play football, collect conkers, or whatever, and it was a big thing for us to just get a glimpse. I must say, though, my main impression then was that it was more like a jail than anything else.'

One strong memory is of the day the Pope came to town, addressing an audience of one million people in the Phoenix Park. 'It was an overpowering sort of a day. He was a relatively new Pope and was expressing, at that time, many views that people wanted to hear.' Fran was there with his parents and, apart from the huge excitement of it all, he remembers the event itself being quite disorganised. For instance, the later you arrived, the better your viewing spot. Still, in the end it was the excitement factor that won out, and he still remembers the day with great fondness.

There's also a romantic element to Fran Rooney's Phoenix Park snapshots. 'Just after I met my wife – she was flying back and forth from Spain at the time – we spent a great deal of time walking here, and it was on one of those walks that we decided we wanted to live in Castleknock, as close to the park as possible.'

In time, the couple married here. Well, not the actual ceremony itself, but the post-wedding reception was held in what was then the Phoenix Park Racecourse, smack bang in the middle of the domain that held such memories for both of them.

And the memories continue to tumble out as he talks about this special place – the picnics with his parents in the People's Gardens; attending concerts in the 'hollow' close to the entrance to the zoo – 'it was a natural amphitheatre'; taking his own son, years later, to the steps of the Wellington Monument; catching pinkeens in the pond; learning to drive here; attending, in recent times, the American ambassador's Fourth of July party in that impressive residence at the heart of the park … 'I have so many vivid memories of it, from all through the years – it makes me realise just how important the Phoenix Park is in my life,' he says.

And yes, he does feel that as a city we don't care enough about it. 'It's totally under-appreciated by the people of Dublin,' says Fran Rooney. 'I mean, to walk across the park in the early morning, through the meadowland, and to suddenly come across a herd of fallow deer … to have that a couple of miles from the centre of a capital city. What more could you ask for?'

Fran Rooney is chief executive of Baltimore Technologies, a worldwide company which provides on-line security systems. A former Shamrock Rovers soccer player, he trained as a chartered accountant and worked for companies such as National Irish Bank and Meridian International before being appointed chief executive of Baltimore in 1999. The company is Europe's largest independent software security firm.

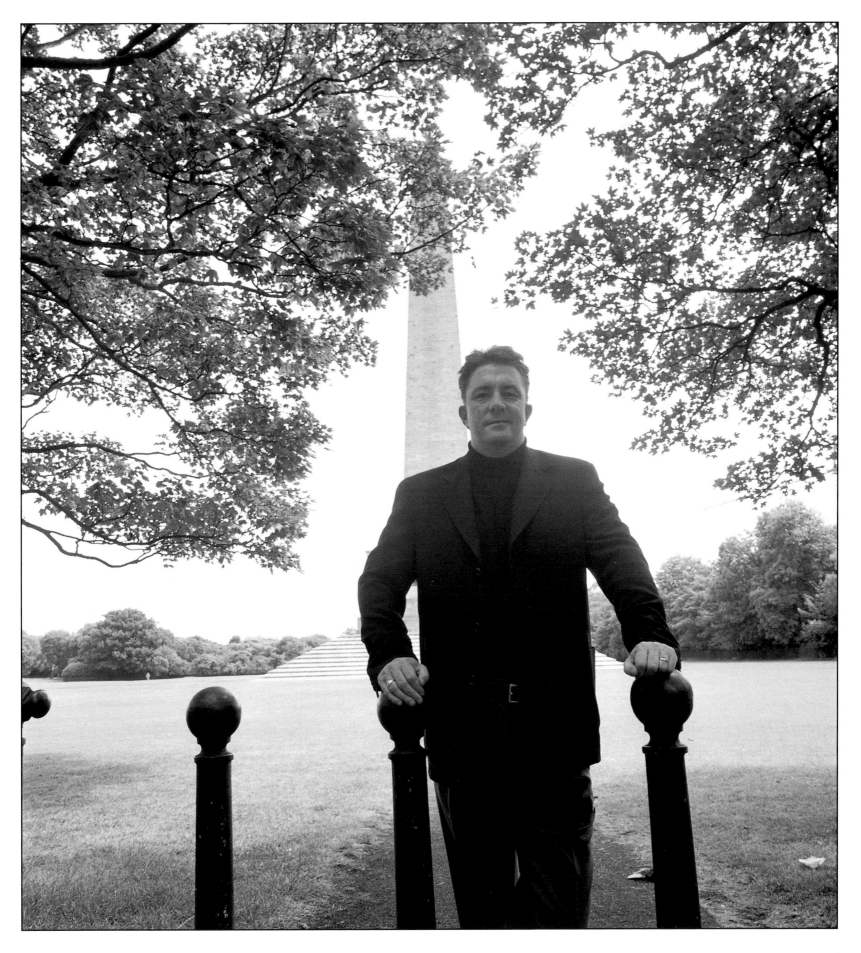

Joe O'Connor

Dublin Airport

Joe O'Connor, the airport novelist, (far right); the bookshop: 'so reassuring to wander in and see people actually buying my books' (above)

Like William Wordsworth, Joe O'Connor has 'travelled among unknown men'. But none quite so unknown as the Green Army that he accompanied to the US, for the soccer World Cup finals, in the summer of 1994. It was a defining moment in Joe's own travels, one of many moments of magnitude experienced, or witnessed, amid the hallowed halls of Dublin Airport.

His assignment at the time was to travel with the fans and write about it for *The Sunday Tribune*. He admits himself that he hadn't a clue what to expect. 'I walked into the airport very early in the morning to check in,' he remembers. 'I knew nothing and I was very nervous so it was great to arrive and see this sea of insanity – I was the only person wearing normal clothes! There they all were, these out-of-condition, hungover men, dressed from top to toe in green and, even early in the morning, still on the tear. We stopped off at Shannon (a joke in itself) and there was this terrible convergence on the bar. It was carnival, it was Mardi Gras'. But it calmed him down. 'I realised that whatever it was all going to be like, it certainly wasn't going to be dull.'

This is just one extract from Joe O'Connor's selected tales of Dublin Airport.

It's a place where he currently spends a lot of time to-ing and fro-ing between Ireland and London. It was also familiar territory for him some years back, when he was part of what he calls 'the Ryanair generation'. And its associations go further back, somewhat nostalgically, to his childhood.

'I always felt an attachment to Dublin Airport as a kid,' he says. 'My father was an engineer, and one of his first engineering jobs was on the airport terminal building, so I felt that it belonged to me in some way or another.'

He remembers the excitement of trooping out to the airport in the Sixties to meet returning relatives from far-flung shores. He recalls specifically the arrival of an uncle from Australia and other family members from England. 'When relatives came back,' he says, 'there was a sense of glamour about them – they dressed so fashionably, they looked different from the rest of us. The women in particular ... there was a Jackie Onassis quality to them, an aura of success ... it made Dublin Airport seem like quite an exotic place.'

The airport relationship continued through his college years. He could escape not just out of Dublin for the weekend, but out of Ireland. The Ryanair generation was taking off and London beckoned with its big city lights. After college he left Ireland and emigrated temporarily – 'When I think about it, throughout the Eighties, I was usually at the airport.'

Then, just when Joe finally thought he'd departed from departure lounges, he was back on the airport trail again. The very month he had planned to move back to Ireland permanently, 'I met this woman'. This woman turned out to be his now wife, Anne-Marie, and they began a long-distance courtship which, for

three years, brought him every other weekend to Departures or Arrivals at Dublin Airport.

Whatever about the personal associations, as a writer, the airport is a great place for people-watching. 'If you're of an imaginative bent at all,' he says, 'it's a fantastic place for stories.' He points out that for many people, their time spent in the airport is connected with some moment of crisis – 'A lot of the reasons why people have to travel are to do with a sadness in their lives. It's all there – people in tears, people shouting at kids, it's an emotional place.'

Staying with things literary and blurring the edges, for a moment, between fact and fiction, Joe reminds you of the character of Eddie Virago in his first book, *Cowboys And Indians*. 'Eddie wants to be famous,' he relates, as if talking about a real friend, 'and he desperately wants to be asked by a newspaper to be the subject of one of those 'questionnaires' that they do. He wants to be asked where his favourite place is just so that he can say – "The Departure Lounge, Dublin Airport."'

Joe O'Connor also feels an affinity with the airport because he associates it with his career as a writer. Back to the World Cup in 1994. 'Although I was apprehensive about it all, as a career decision it was really good – that became a springboard for other things.' (There is a substantial 'World Cup stories' section in his book, *The Secret World of the Irish Male.)* 'People who read that book then found their way into my novels.'

He loves the comfort of the airport book shop. 'I often arrive back in Dublin after a reading tour of somewhere like Norway. I've been way up in the Arctic Circle and about seven people have turned up to listen to me. It's so reassuring to step off the plane, wander into the bookshop for something or other and see people actually buying my books, and then sitting around actually reading them. It makes me speechless with happiness.'

Dublin Airport, says Joe O'Connor, is a microcosm of a bigger, wider world. 'The manager in the bookshop comes in at 6.30 in the morning and he's there until around 10 o'clock at night. He hardly leaves the building. It's like a small town in the Midlands – everybody knows each other, they go out with each other, they get married to each other, the men play in a football league together ... yet it still operates on a human scale – it's not like JFK.'

When it comes to all the human traffic he easily identifies with those in pain, those for whom the airport is a reminder of some awful sadness in their lives. And he thinks too, of the Irish soldiers en route to the Lebanon or to some duty overseas. One of those soldiers wrote to him about *The Secret World of the Irish Male,* which his wife had given him for Christmas. He and his friend would put in the time on night duty in the Lebanon, sitting in their armoured car, reading aloud to each other from the book – especially the World Cup stories. One night, he said, they were laughing so loud that their commanding officer heard them, investigated what was going on

Joe O'Connor is a novelist and playwright. His first novel, *Cowboys and Indians,* was published in 1991. He has written several novels since then, including his latest, *Inishowen.* His plays have been staged in Ireland and abroad, and he is also known for his bestselling non-fiction *Secret World* series, the third of which, *The Last of the Irish Males,* is due for publication in spring 2001.

The Departure Lounge, Eddie Virago's favourite place (far right); comings and goings in the new airport bar (above)

and promptly confiscated the book. They were alerting the enemy to their presence, he warned. 'You really could die laughing,' the soldier wrote to Joe.

And now, Joe O'Connor still travels through Dublin Airport on a regular basis. With homes in Dublin and London, he, his wife and their baby son, James, still come and go. He loves the comfort of the place. When it comes to actually stepping into the aircraft, however, you can forget comfort. All his years of flying have not succeeded in

relaxing him. 'It's the only time I ever pray,' he confesses. 'I mean, there you are, thirty or forty thousand feet in the air in a metal box. If something happens you've no chance. You can kiss your ass goodbye.'

Yet the magic lingers on. 'I still get a sense of anticipation in Dublin Airport,' he says. 'The early memories remain very powerful. I still think of it like a Frank Sinatra soundtrack - still exciting, still groovy ...'

Darina Allen

Ballymaloe, Shanagarry, Co Cork

Darina Allen in the vegetable garden: 'decorative as well as functional' (far right); echoes of Versailles in the herb garden (right); Lydia's garden (above)

Darina Allen is a celebrity chef who owns and runs the Ballymaloe Cookery School in Shanagarry, Co Cork. Educated at the College of Catering in Dublin's Cathal Brugha Street, she was presenter of the highly successful *Simply Delicious* television series on RTE. She is the author of numerous cookbooks and has been outspoken in her opposition to GM foods. She lives at Kinoith, in the grounds of the cookery school, with her husband Timmy and their four children.

The first things you notice are the hens. Not just any old hens. These are the supermodels of the fowl family and they strut their stuff on the lawns and pathways at Kinoith as if they owned the place. They are quite beautiful - glorious in their colouring and imperious in their bearing, squawking at you and heralding your arrival in no uncertain terms. Guardians of this Regency house of Kinoith, guardians of the kingdom, as it were. This Shanagarry kingdom of Ballymaloe.

Queen of this realm is, of course, Darina Allen. And it's many things, this kingdom in east Cork: farm, internationally famous cookery school, wondrous collection of gardens, covered one-acre organic vegetable 'patch'. Yet whilst Ballymaloe is all of these things, it is, above all, an idea - an idea that has now become a way of life. This is not where Darina Allen was born, nor is it where she grew up but it is, you sense, where she found herself. She doesn't actually say anything as twee as that, but when you spend time with her there - walking the gardens, traipsing through the greenhouses, peeping into the pristine kitchens of the cookery school, looking at the hens and the other animals - you quickly realise that this is not just the place that means most to her, but rather the place that defines her.

It's all about growth. When every new batch of students arrives here for a stint in the cookery school, instead of letting them don aprons and take up utensils, she leads them out to meet one of the gardeners. Each student is then given a seed to plant, and Darina talks to them about the growing process, about earthworms - 'one of the most fascinating little beings' - about everything connected with growth and the earth. 'The students,' she says, 'are bewildered. They've come here to cook. I know they are looking at me and thinking to themselves, who is this grey-haired hippy woman? But there really is no better way to learn respect for food than to plant a seed and watch it grow.'

She has no favourite spot within this 100 acres that is her home, her business and her passion. But as you walk with her through the grounds you detect a special fondness here and there. In the fruit garden, for example, just underneath the window of the cookery school dining room, she proudly shows off the olives, the white mulberry, the almonds, the damsons, the old apple varieties. In the spring, she tells you, it's really beautiful, because the whole garden is underplanted with spring bulbs.

She touches as she walks, smells the roses, fixes things, removes twigs, always looking to fine-tune, to improve. The main gardens, essentially three separate spaces, are stunning. 'It was a complete wilderness when we got the house in 1970,' she remarks. 'We had lived here for about six years before we started putting the gardens back - it really was a voyage of discovery.' The first, and most romantic, of the gardens is called Lydia's Garden, named after the former owner of the house, Lydia Strangman. 'We discovered old watercolours of the garden that she had done herself,' Darina Allen explains. 'Her diaries were also here and we've always felt close to her.' Darina and her husband Timmy named their eldest daughter after her and later discovered, in one of those shiver-down-the-spine moments, that *their* Lydia was born one hundred years to the day after Lydia Strangman.

The herb garden is a masterpiece of geometrics. The word 'Versailles' had sprung to the lips of a friend in her attempt to describe it to me before my visit, and certainly the French connection is a valid one. In the planning of it, Darina Allen visited the Loire region of France in her search for inspiration. You can walk amid the box-hedged herbs, or you can climb to a tree house which straddles the area between Lydia's garden and the herb garden, and look down over the scent-filled canvas.

The third garden is completely different, large and rambling, 'with lots of places for the birds', a feature temple, and a pond. There's a nut walk and masses of fascinating shrubs. 'Every year,' Darina explains, 'we seem to find something else that has survived.' The folly, or temple, is actually the portico from a old house in Co Kilkenny. 'We intended to do something grand with it but didn't,' she says, 'and now I rather like it just standing there looking forlorn.'

There is one spot in the grounds that seems rather personal, a spot that in some way manages to encompass the sense of family that exists here. This is the Shell House, a summer-house whose interior walls are decorated entirely with thousands upon thousands of shells. It was built in 1995 and, as Darina herself puts it, 'developed into something of an extravaganza.' Growing up in the Midlands, she always had a longing for the sea and all that went with it. A few days on holiday in Tramore were the highlight of her

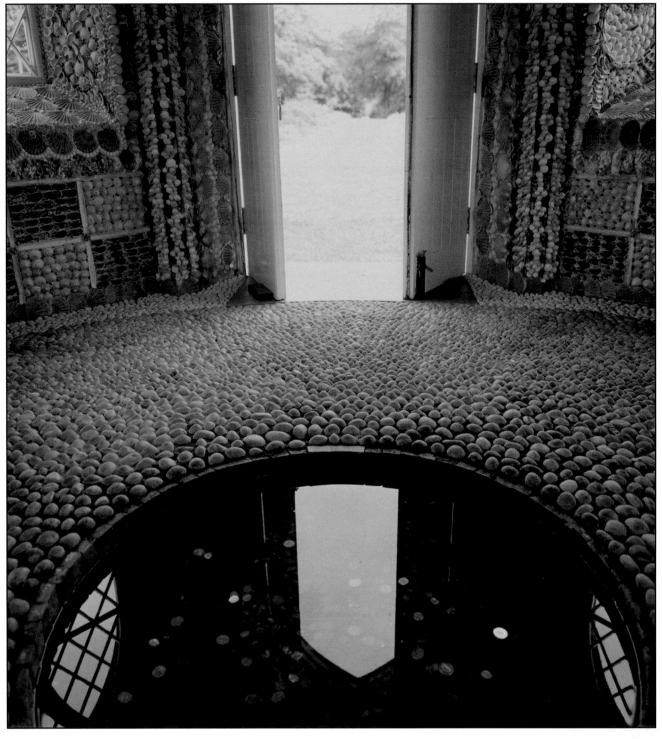

year. So she brought the sea to Kinoith in the shape of her Shell House, five months in the making and now exuding an air of calm amidst this hive of activity. If you look closely you can see the initials that are formed by the shells - those of Darina and her husband and those of their children. She loves it here and admits that this is where she escapes from the fray: 'I really do feel like meditating when I'm here.'

But at its heart, Ballymaloe is about growing. Things might *look* beautiful - the Shell House, the vegetable garden ('I decided that it might as well be decorative as well as functional'), the colour-laden herbaceous borders, the saddleback pigs that scurry around the place, the extremely handsome hens - but in the end it's the organic,

almost holistic, nature of the place that leaves its impression. That is what is important to Darina Allen. That's why she loves the look of her lawns peppered with daisies, that's why she leaves great swathes of land brimming with nettles and buttercups, that's why she's getting into seed saving and that's why she recycles, grows her own, keeps putting something back.

'I love the soil and the compost,' she says. She doesn't need to tell you this - just watch her diving down and kneeling in it, touching it, running her hands through it, examining it. Perhaps her own comment is most apt - despite this international cookery 'empire' over which she now presides, Darina Allen is really just a grey-haired hippy at heart.

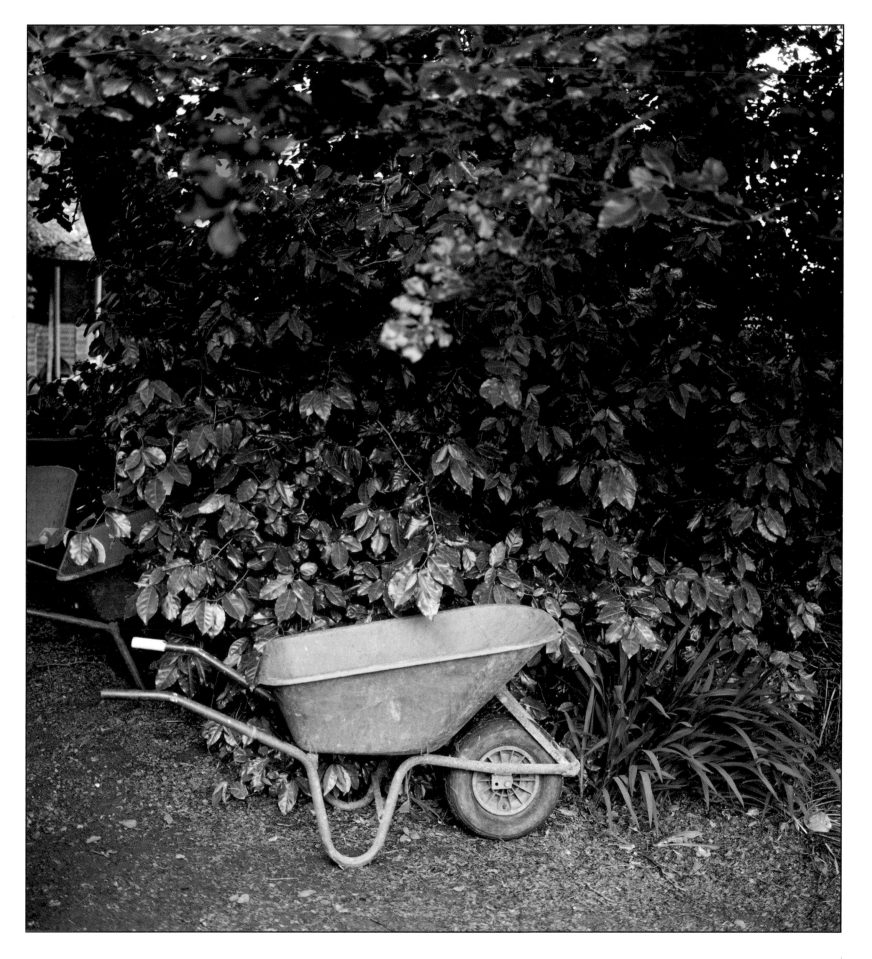

Mark Mortell

The Crab Rocks, Bray, Co Wicklow

Mark Mortell on the edge of the Crab Rocks (far right); the view from the rocks around Bray Head (right); looking back towards the town's seafront (above)

Mark Mortell is commercial director of Aer Lingus. After attending Dublin City University he worked for a number of companies including Guinness and Bank of Ireland. He has been managing director of Dimension advertising agency and chairman of Bord Fáilte. He currently sits on the executive of the Irish Tourism Industry Federation. He is married with two daughters.

In the town where his father grew up and where he himself would live out his teenage years, Mark Mortell had a 'special' place as a young boy, one that still evokes all kinds of happy memories; a real father-and-son spot which, to a child, must have been magical.

'It's a place in Bray,' he says, 'that we called the Crab Rocks, beyond the cove at the end of the prom. You walk out to the end of the prom, then out the cliff path until you feel that you're right under Bray Head. There's a little cove there with big rocks, and from the end of May until August the crabs come there to mate.'

Imagine a little five-year-old boy walking out there with his father and his brother, in search of crabs and adventure. 'It's one of my earliest memories,' he says, 'driving out from Dublin to my grandparents' house in Bray, gauging the tide to see when we could go to the rocks – you quickly learned all about those kinds of things. Then a quick visit to my grandparents' house and off down to the Crab Rocks, us boys and my Dad. We had to cross the railway tracks to climb down to the rocks; it felt very exciting, a really big adventure for children.'

His memories remain vivid – how his father could climb right out to the furthest rock; how, as a small child, you learned great balance scrambling over the crags; and how, of course, you learned to actually catch the crabs, the real object of the whole exercise.

Mark still speaks with the voice of an expert. 'You'd kneel down and look right under one of the rocks. There would usually be two crabs there – the cock crab at the front and the hen at the back. The hen is always bigger and more meaty and her shell goes soft when she is pregnant. You'd shove your hand in and pull. Once the crab was out you'd lay him on his back. We'd catch six or seven on a good tide.'

When they'd caught their fill, father and sons would clamber back up to the cliff path and make their way triumphantly to the grandparents' house on Putland Road. He recalls the reactions of people to the sight of this trio meandering along on a summer's day complete with their kill. 'The day-trippers would be out along the cliff path and they'd be looking at us with our crab catch,' he says. 'There were all sorts of comments.'

Such as?

'Such as, "Jaysus, Ma, look at them with their big spiders!" Even as a small child there was something very macho about how it made you feel,' he remarks, still amused by the memory of it.

Then it was back to the house – to clean, boil and eat them. 'You learned the bits you could eat and those you couldn't. We'd mix up the crab meat with breadcrumbs and vinegar and put it all back into the clean shell. Delicious!'

Those trips to the Crab Rocks were the first brushstrokes on what was to become a larger Bray canvas in Mark Mortell's life. That five-year-old boy could not have known that less than a decade later, at age fourteen, his parents would split up and he would move, with his father and brother, to live with his grandmother in that house on Putland Road. Back to within walking distance of the Crab Rocks. Back to his childhood.

'When I think about Bray now,' he says, 'there are so many connections going on – my Dad's youth, my early childhood, my own youth … I spent some of my happiest years there.'

That dramatic shift of life as a teenager was a catalyst to many more changes. He'd been at school in Blackrock, now he was at school in Presentation College, Bray. He had to, as he says, 'create a whole new bunch of friends'. He also discovered that he had much to live up to.

'My Dad had been to school at Pres and he'd gone on to play rugby for Ireland. There was a portrait of him hanging in the school. It took me a while to settle.'

But settle he did. In fact, he did more than settle. He flourished in the atmosphere of a smaller, more intimate school. 'There was,' he remembers, 'a community feel to the place.' He took up debating, which gave him self-confidence and, with the school functioning as one cog in the wheel of the larger Bray community, he 'started to get involved in running things, to emerge in that kind of direction. I still feel a great gratitude to those years and to that time,' he says.

Although Mark Mortell does not live in Bray anymore, he still loves the place. The town, the Crab Rocks, the sea. He is now the father of two daughters and, in the way that cycles repeat themselves, the girls now look forward to trips to *their* Dad's special place. For now Mark is the master in the crab-catching rituals, and his daughters the apprentices; taking their lead from him, peering under rocks and daring to thrust in their hands just like he did all those years ago with his own father.

He still yearns, he says, 'for the smell and the freshness of the sea. I don't fear it. My close encounters with it as a child meant that I saw it for its power and in all its various moods. When you have an experience like that you develop an affinity, an affinity that stays with you forever.'

Carmel Moran

McDowell's Happy Ring House, O'Connell Street, Dublin

Carmel Moran on O'Connell Street: 'this is my territory' (far right); the historic jeweller's clock (above)

'**When my mother passed away** this summer, we took her from the Pro Cathedral and out to Glasnevin via O'Connell Street, past Number 3, McDowell's Jewellers, and do you know what happened? The staff all came out of the shop, and stood silently on the pavement as we passed, as my mother made her final journey. You see, my family has been associated with this building for three decades. It's the place where I saw my father carried down the stairs on his way to *his* final resting place. To me, it's more than a building – it has huge emotional meaning attached.'

So says Carmel Moran, O'Connell Street's only resident, about the place that most Dubliners know as The Happy Ring House, almost directly opposite the GPO at the top of the street. She lives on the top floor, eyrie-like, and views the country's main avenue through what she thinks of as the eyes of the building.

'I always call this place "her",' she explains, 'so watching through my windows is really watching through her eyes. Whenever anything happens down there, I say to her, "Here we go again, old girl."'

And, as an edifice, it has undoubtedly seen it all down the years. In the jewellers itself, there are letters on the wall dated 1902, when McDowell's still had its 'Sackville Street' address. 'What strikes you most,' says Carmel Moran, 'is the sense of history. It would be impossible to live here without that. I can never watch O'Casey's *Plough and the Stars*, for example, without being really moved by the scenes of looting in the days after the 1916 Rising. You see, Mr William McDowell had stayed on in this building when the rioting was going on. There was just himself and the porter here, and when they realised that things really were getting out of hand, they decided to try and leave. Mr McDowell was shot in the leg and the porter was shot dead. That's the kind of history attached to this place. Some of the girders from the GPO were even incorporated into its restoration.'

Carmel Moran describes her own associations with it as 'a play in three acts - the Seventies, the Eighties and the Nineties. My Dublin of the Seventies was a quaint little place. There was O'Byrne and Fitzgibbons, gentlemen's outfitters near the Savoy cinema, and Madame Nora's, with its lingerie, blouses and handbags, where you really were served by Nora herself ... and Dargan's, the chemist, where there actually was a Mr Dargan. Like McDowell's, where even today family members Peter or John McDowell are always in attendance.'

The early years of the Seventies were, she says, 'an age of innocence', but her memories of Number 3 and of O'Connell Street are not all of the rose-tinted variety. 'It's like a kaleidoscope of bitter-sweet recollections,' she says, 'with moments of high humour and bleak tragedy.' The end of innocence, the great watershed for the street was, she says, the day of the Dublin bombings.

'I was standing at the top of Henry Street when the first bomb went off. I'd seen and heard explosions before in Northern Ireland. "Oh my God," I said, "that's a bomb." A young man turned to me and said, "No, no, it's only a car backfiring." But I knew. There was an atmosphere that hung over the street. I knew two people who died that day.'

Northern Ireland was to touch Carmel Moran's life again, this time in the early Eighties when, at the height of the H-Block riots in O'Connell Street, she and 'the old girl' weathered the storm together. In spite of garda protestations, she stayed put indoors, while battle raged on the street. 'To hear the sound of the plate glass windows going in ...' she remembers, 'it was like watching the 1913 lock-out re-enacted in the television version of *Strumpet City*, only this was real.'

There was little joy here in the late Seventies and early Eighties, says Carmel, 'nothing to celebrate'. Then came President Mary Robinson. 'I remember the day of her inauguration, standing in my front window waving a scarf and saying to the building, "Did you ever think we'd live to see this?"'

From her prime vantage point, Carmel Moran has witnessed great change, and what she describes as 'a desperate carnage resulting from bad planning. The Capitol cinema, originally the opera house - gone; the Carlton site left derelict, the demise of Gill's bookshop'. Yet still she enjoys the view from her tower, relishing the scenes that all manner of street life brings. 'At night time it's at its best,' she says, 'very, very late, when it's peaceful and quiet. It's hard to believe, but it does get like that at night.'

And then there are the 'characters' that she watches from her window, or meets on the street. 'A lot of them are disappearing,' she says. Some are already gone. Like Abrahim, the street photographer. 'My late father and Abrahim always talked,' says Carmel Moran. 'My father had a particular interest in photography and after his death, Abrahim came up to me one day and told me that he'd been in the synagogue the night before. "I hope you don't mind the prayers of a Jewman," he said, "because I prayed for your father."'

Then there was Jimmy, the homeless man who stood outside the GPO and seldom spoke, but whom Carmel used to supply with cigarettes from time to time. 'He never took any more than two, one for now, and one for later. One night there was a ferocious storm and I looked out and saw him sheltering under the canopy at the GPO. I wondered what I could do to help him so I went into the kitchen, made sandwiches and heated Baxter's soup. Then I rang the local police station and told them that I'd heard a noise in the building and asked them if they could call round. Round they came and I confessed that I'd called them under false pretences. Could you take these over to Jimmy? I asked them, handing them the soup and sandwiches. And they did. Then, as they were leaving, driving back up O'Connell Street, they must have seen me watching from my window and they flashed their headlights at me.'

It's that feeling of community that Carmel Moran loves about the street. Much of it may now have vanished, as the presence of the chain stores increases, but for Carmel Moran, herself part and parcel of street life, remnants of it remain. Such as the women that Carmel

Carmel Moran is a third-generation Dubliner. Before she migrated to O'Connell Street where she is the avenue's only resident, she grew up on the South Circular Road, in the part then affectionately known as 'Little Israel', due to its large Jewish population. Always returning to Dublin, she has lived in Cork, Limerick, Galway, Luton and London. She has worked as a crystal glass company representative, in advertising, in staff recruitment, and once presented a programme on Horizon Radio.

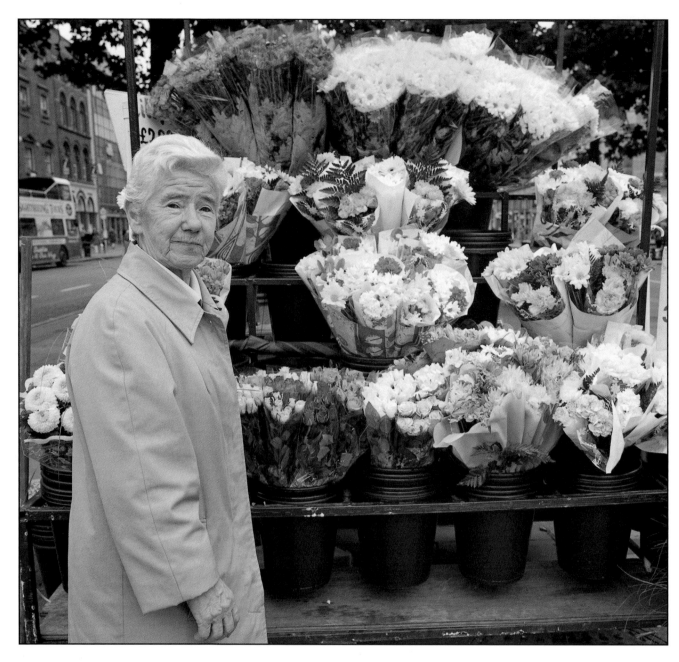

calls 'the Lattimore girls', the family who for four generations have been selling flowers, day in, day out, from their pitch on the central island right across from the McDowell's building. 'I may not have actual neighbours,' says Carmel, 'but I am surrounded by people who are very kind. I was hospitalised some time ago, and my sister Irene came in to visit me carrying a big bunch of flowers. "You'll never guess who they're from," she said. It was the Lattimore girls. It's not so much that I've adopted this street as that the people here have adopted me.'

When Carmel Moran meets people for the first time, it certainly gets the conversation going when they discover that she lives on O'Connell Street. 'People tell you things like, "My mother got her engagement ring in McDowell's", or ask, "Are you not terrified living there?" But what on earth would I be frightened of? I'd be far more terrified in the suburbs. This is my territory.'

O'Connell Street is, of course, more than just her territory; it is her home, on a boulevard that no one else can call home. The late Jack McDowell, uncle of the current owner, Peter McDowell,

and the man who famously bought out the mail boat bar with drinks and food for everyone on board after his horse won the National at Aintree in 1947, used to take great pride in telling Carmel Moran that it had been his home too, that he was actually born in the part of the building where she now lives. And although that residential aspect to the street is no more, says its remaining inhabitant, 'I'm very proud that this building has endured. The old girl and I have soldiered through good times and bad times, bonded together to such a degree that it's something like a marriage vow – in sickness and health, for better or worse ... like Dylan Thomas said of his home town of Swansea: "A lovely ugly little town". I can empathise with that.'

In the end it's the sense of history that is overpowering for her. 'I've been in the unique position,' she says, 'of being able to watch history unfold from these windows – the first Papal visit, the inauguration of Mrs Robinson, the terrible reverberations from the North. Now the old days are going ... but I'm very glad that because of this building I was a part of all that.'

Derry Clarke

Derry Clarke at the Old Head of Kinsale: 'the wildness of it' (far right); lobster pots on the quayside (right); looking across the harbour (above)

Kinsale, Co Cork

For someone who has scaled the dizzy heights of culinary creativity, winning awards right, left and centre, Derry Clarke is amazingly honest about his humble beginnings in the business that has brought him such recognition. Clearing tables and washing dishes were two of the more lofty jobs first engaged in by the amiable chef/owner of L'Ecrivain, one of Dublin's top restaurants. And it was a long way from Dublin that those particular tables were cleared. Man Friday was the restaurant, Kinsale the place and one with which he has had a long association since early childhood.

'My aunt and uncle lived just outside Kinsale,' he explains, 'and from when I was about eight I used to go and spend a month in the summer with them.' His uncle had a boat and, as a young boy, it was a magical place to pass a few holiday weeks. Long before he realised the significance that her business interests would have for him, Derry's aunt was already in partnership with a man called Peter Barry. The business in question was Man Friday restaurant, now something of a Kinsale landmark.

'I never thought I'd go into the restaurant business,' says Derry Clarke, 'but when I was about fourteen I started clearing tables over the summer in Man Friday. The following year Peter Barry said to me "Why not go into the kitchen?" and that was it.'

Derry worked in Man Friday for the next few summers and, after leaving school in 1976, he began working there full-time. 'Peter Barry encouraged me to stay,' he says. 'He thought that I had a natural flair in the kitchen.'

So Kinsale changed for him; no longer just a place to hang out in the summer holidays, it became his home. But more than that, it became a place of great personal importance, and now, a quarter of a century later, it remains a part of his past that is firmly connected to his present life. He still loves it, still goes back from time to time, still has friends there.

The first draw, of course, remains the most powerful one – the sea itself. He had, after all, originally considered a career where the sea would feature prominently, almost ending up in Greencastle, Co Donegal to do a fisheries course. But Kinsale and the kitchen of Man Friday lured him back and he lived a life there, though not directly dependent on the sea, in close proximity to it. He loved the freedom of it all, its otherworldliness. 'It's still special,' he says. 'When I was a child it was like another world, another country ... it was like a completely different culture.'

Derry Clarke feels strongly about what he calls 'real rural freedom'. Nowadays he lives with his family near Saggart outside Dublin and his house affords him views both of the mountains and the sea. 'From our window we can see the sea – the whole sweep of the bay from Dun Laoghaire to Naas. I like the rural feeling that living there brings,' he says. 'I much prefer it to the urban experience.' It's connected with the feeling he still gets when he sits into his car to drive somewhere down the country. Somehow it seems to transport him back to travelling to Kinsale as a youngster and as a young man.

That freedom wasn't just in the travelling of course. It was in the working and the living there. The restaurant business, in a seaside town, was fairly seasonal so he was able to take great chunks of time off from his Man Friday duties, especially in the winter. 'When I was about twenty-two or twenty-three,' he remembers, 'I'd go travelling abroad for the winter before coming back again to the job in Kinsale. I didn't really take the job that seriously – it's funny, and people find this hard to believe, but the restaurant business still isn't my main life.'

So what is?

'My family, of course, but also freedom; I like to hang on to a sense of adventure and freedom.'

Kinsale has changed now, of course. It's busier, more touristy, displaying a higher quota of hanging baskets than in the old days. 'It's a prosperous town in its own right,' says Derry. 'It's got a cosmopolitan atmosphere – the architecture is striking ... it's still a Spanish town.'

And if he had to isolate a particular spot, a special place particularly dear to his heart, where would that be?

'The Old Head of Kinsale,' he answers, without a moment's hesitation. 'There's nothing like it on a summer's day. Just walking there, by myself, and looking out over the sea. The wildness of it – it gives me a free, open feeling, but also a sense of peace. Do you know what it's like? It's that feeling you get that tells you that life is good.'

So the romantic image still endures, the world still seems like a place with endless possibilities. 'As a kid,' says Derry Clarke,' I'd look out at the sea off Kinsale and realise that the world was so vast ... it made me wonder about all the things that you could do with your life. I'd watch ships passing, far out on the horizon, and wonder where they were going to, where they were coming from ... it opened things up ... I became aware that there was a whole other world out there.' On a less global scale, the romanticism continued. It's even captured for Derry Clarke on the sign posts of the West Cork area – 'Crookhaven, Clonakilty, Ballydehob ... even the place names have a special ring to them.' But ultimately, it comes down to the juxtaposition of Kinsale and the sea, and in an unselfconscious but very telling way, Derry Clarke manages to use the language of food to convey why they still mean so much to him. 'In the end,' he says, 'it's all to do with the aromas of my childhood.'

Derry Clarke is a chef and restaurateur. Along with his wife, Sallyanne Clarke, he runs the award-winning L'Ecrivain restaurant in Dublin. Founded in 1989, it has received acclaim from the Michelin, Bridgestone and Egon Ronay food guides. A past president of the European chefs' association of Euro Toques, he lives in Co Dublin with his wife and two young children.

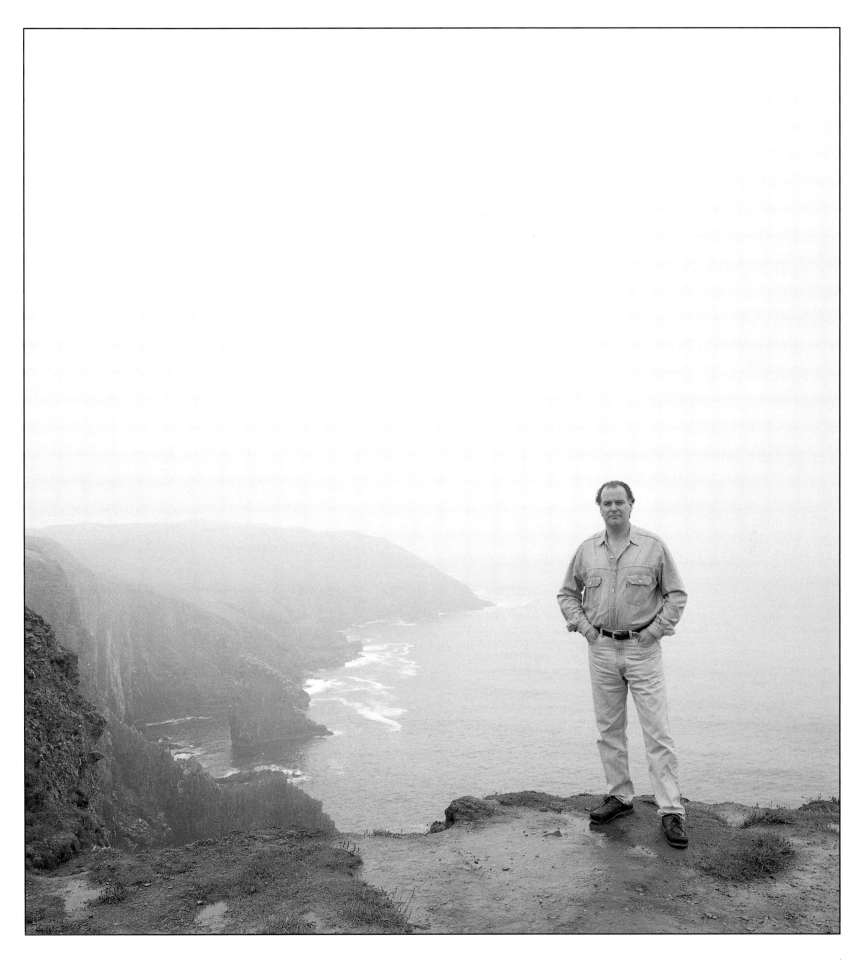

Mike Allen

Mussenden Temple, Castlerock, Co Derry

Mike Allen 'standing in the middle of the sky', across the fields from the Mussenden Temple (far right); the temple itself, monument to a lost love (above)

Mike Allen is general secretary of the Labour Party. He studied genetics at Edinburgh University, worked as a teacher, and has been involved in numerous literary projects, including The Galway Writers' Workshop. Previously general secretary of the Irish National Organisation of the Unemployed, his book on that subject, *The Bitter Word*, was published in 1999. He is married to journalist Susan McKay and they have two daughters.

'I'd met Susan in Belfast, we'd taken our daughters to a dinosaur exhibition and as we were driving from Belfast to Castlerock we heard the news on the radio. The bomb had gone off in Omagh. We were shocked at the arbitrariness of it. We reached Castlerock and, somehow, without really talking to each other about it, we left the cottage and walked up to the temple. It just seemed like the natural place to go.'

For Mike Allen, the Mussenden Temple, perched on the clifftop outside Castlerock, provided, on that August day, sanctuary of some kind from the horror that was beginning to unfold sixty miles or so up the road in Co Tyrone. For him, the temple is not a childhood place, but rather somewhere that has played a role in his life only over the past decade. It's setting is impressive, out on the edge of the world, standing guard on the crumbling cliff high above the Atlantic. The gigantic ruins of the Bishop of Derry's palace are across the fields behind it to the south, the Scottish island of Islay far across the sea to the north, the headlands of the Giant's Causeway to the east and, to the west, with the Donegal hills rising behind it, the dramatic sweep of Magilligan Strand stretching forever into the distance, some two hundred feet below.

Mike Allen grew up in South Wales and Ireland for him is very much part of the landscape of his adult life. About ten years ago the journalist Susan McKay, now his wife, brought him for the first time to this bleak Atlantic coastline, a part of the country that is family territory for her. Mike remembers that it was out of season, with no cars glistening side by side on Castlerock beach, and he recalls walking up through the Black Glen above Castlerock, to reach the Mussenden Temple.

Just outside the entrance to the glen is a row of twelve terraced cottages, known locally, in this part of the world where church and chapel hold such sway, as The Twelve Apostles. One of these is a cottage that has been a bolt-hole, an escape from city life in Dublin, for Mike and his family over the past decade. From there, access to the glen is practically immediate and a steep walk up through it and across a series of fields brings you to the temple, clinging perilously to the clifftop. Built by the Bishop of Derry between 1783 and 1785, it was dedicated to one Mrs Mussenden, the daughter of his cousin. Born Frideswide Bruce, the young woman and the bishop apparently enjoyed a close relationship, which caused some scandal in its day, scandal which came to an abrupt end when she died at the age of only twenty-two, before the temple was completed. 'I intend to build a Grecian temple in Frideswide's honour ... elegant, exquisite, looking towards the sea', he wrote at the time, and now this monument to the bishop's lost love is a stunning, folly-like structure that acts as a classical beacon along this area of coastline.

'When I was writing a book a few years ago,' says Mike Allen, 'I spent a couple of two-week periods on my own in the cottage in Castlerock. Each day I would go for a long walk through those grounds. In the first part of the glen there's a lake and then, when you get right up to the top, you feel that you're standing in the middle of the sky.'

At that point, only one obstacle remains between walker and cliff-edge: 'To get to this exotic piece of classical architecture,' says Mike Allen, 'you have to walk through a field full of sheep. It's extraordinary – all these different elements in a very small space.'

The cottage, Castlerock and the temple have been, as Mike Allen describes it, 'an extension of family life' for a few years now. After their eldest daughter, Madeleine, was born, Susan McKay was working on a television script and based herself in Castlerock whilst writing. Mike has strong memories of travelling up to see her and his little daughter every weekend. He'd take the Dublin train as far as Belfast and, from there, switch to the Derry line, meandering through the countryside – 'through places like Cullybackey,' he says, 'as the sun was setting' – then on through Ballymena, Ballymoney, Coleraine and finally to Castlerock, 'getting off at the station and walking up the hill to the cottage.'

He spends most of his summers here. When his wife was working on a book a few years back, she moved there with the children, who attended school in Castlerock for a period. Indeed the youngest girl, Caitlin, actually began her schooling there. Again the ritual of Mike's visits remain prominent in his memory, as does 'Marching Season' time, when Susan McKay worked as a journalist in the North.

Although Mike Allen is not altogether comfortable with this particular aspect of the little Castlerock hamlet, he laughs at the memory of daughter Madeleine's first impressions of the red, white and blue-painted kerbstones in downtown Castlerock. 'When she was about four she loved them. We'd drive into the town and there they'd be, and she thought it was like going to a party.' But whatever about the humour courtesy of a four-year-old, there remains for Mike a certain unease regarding life in this otherwise 'idyllic' place: 'I feel at times uncomfortable about enjoying myself. There's a definite realisation that you're in a society that is not at ease with itself. It's different in Donegal or wherever. OK, there's still poverty, there's still unemployment, but it doesn't hit you right in the face like it does in the North.'

Despite the many summers here, he likes it best in the spring, when the glen takes on a hue of blue, such is the profusion of the bluebells. And then there's the wild garlic. 'Before the girls were born we'd often go up to the glen and collect the leaves,' he says.

While Mike Allen's empathy with the whole of this now National Trust property is obvious, it is the Mussenden Temple that has one very special resonance for him – he got married here. It's hard to imagine a more romantic or perfect setting and yet, he says, they took a great risk with the temple as a wedding location. He explains the vagaries of the weather on this north Atlantic coast. 'It was a fifteen-minute walk from the car park to the temple and we knew that if the weather was bad, it wouldn't just be bad, it would be

On Magilligan Strand at Downhill (far right); a folly in the grounds, near the ruins of the Bishop of Derry's palace (above)

unbelievably miserable.' As it happened it was a beautiful May day complete with backdrop blue sky.

'Everybody who mattered to us was there,' he says, 'people from different stages in both our lives. I remember being disappointed because my best friend from my schooldays in Wales couldn't make it. Then, the day before the wedding, I was crossing the fields near the temple and someone was walking towards me. I thought to myself, I'd swear that's Richard Jones. And it was – he'd made it after all.'

Mike talks about how the Mussenden Temple looked that day, how they transformed the inside of it with flowers and candles, with music, poetry and, of course, with people.

'When I come here now and see it empty again, it's really strange,' he says. Yet you imagine that he loves the emptiness too, taking pleasure in the silence of this place right out on the edge of Ireland, this temple, built over two hundred years ago as a celebration of love. Still a place where love is celebrated, still a place of sanctuary.

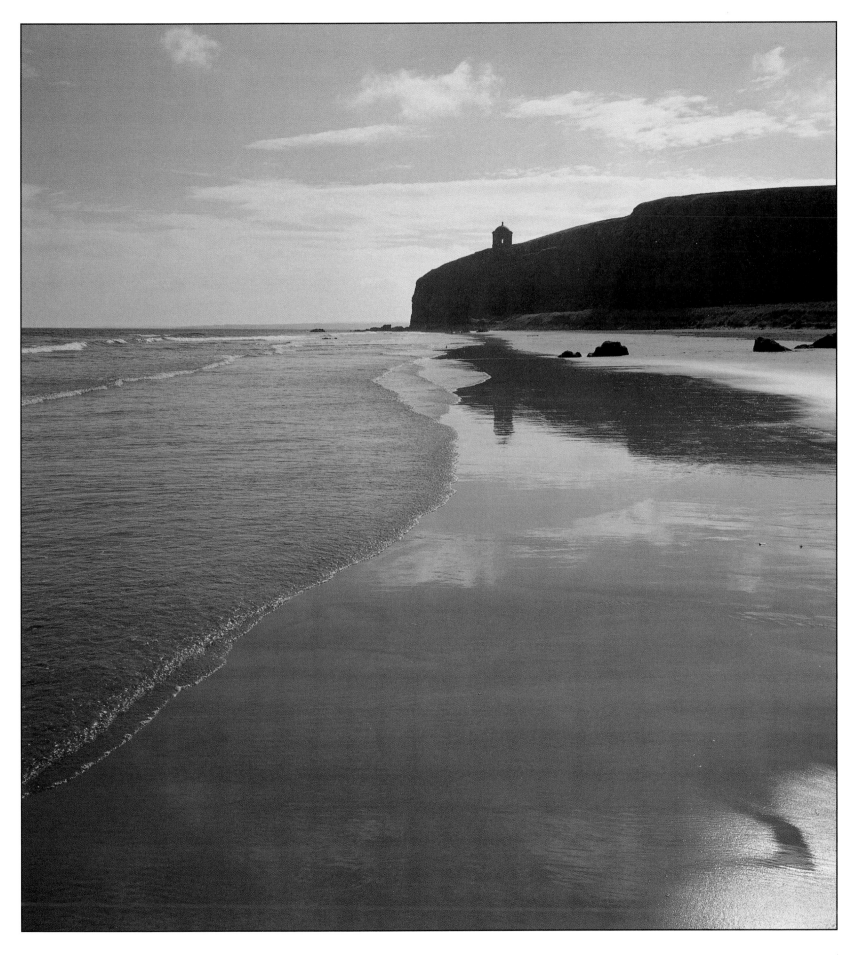

John O'Conor

Tyrone Guthrie Centre, Annaghmakerrig, Co Monaghan

John O'Conor, piano man (far right); in the garden of Annaghmakerrig (right); the front facade of the Tyrone Guthrie Centre (above)

'**There's a big room,** right at the back of the house, a room with bare floorboards – and a piano. Just a piano. It's where, back in the Fifties, Tyrone Guthrie tutored the actor Alec Guinness for his role in *Richard III*. The room right next door is where I always stayed.' John O'Conor on Annaghmakerrig, the artists' centre set amidst the stony grey soil of Paddy Kavanagh's Co Monaghan.

Established almost twenty years ago as an artists' retreat, it is well-known as a haunt for writers. But for musicians?

'Yes, I know,' explains John O'Conor, 'not many people realise that musicians use it too. It's a really special place. It gives artists tremendous freedom. It's a wonderful place to spend time.'

There are actually two pianos there – one in a general, drawing room area, to be bashed on, you imagine, by whoever fancies a tinkle on the ivories; the other, that of the aforementioned Alec Guinness room. 'Musicians in Annaghmakerrig live in the room beside the piano room,' explains John O'Conor. 'It's above the back kitchen at the top of the house, so there's no real problem with the sound disturbing anyone else. Sometimes in the summer, though, when it gets warm, you'll be gently admonished for opening a window.'

John O'Conor first visited Annaghmakerrig in 1982, on 15th February to be precise. He remembers the specific date because he'd been on the *Late Late Show*'s Valentine programme the night before. He was apprehensive about his first visit, an anxiety not helped by a fellow *Late Late* guest describing it as 'a terrible place'.

But terrible it wasn't. Both professionally and socially, John O'Conor found it invaluable. 'There's no television, no radio, no telephone except in an emergency ... I went there first to get to grips with Beethoven's 'Hammerklavier Sonata'. I needed to get away to concentrate on it. I practised for ten hours a day.'

As a counterbalance to that isolation, the sociability of the place kicked into action. 'I met people here I would never have met otherwise – Dermot Bolger, Michael O'Sullivan, Colm Toíbín. I made life-long friends – Paul Durcan, Nuala Ní Dhomhnaill, the artist Kay Doyle ...'

And so he returned. After that initial visit in 1982, he went back every year, through the Eighties and well into the Nineties, for ten days to two weeks at a time. 'Any longer would be too much because of the intensity of the work. When I was here I'd practise ten to twelve hours every day.'

Whatever about the hard work, the routine in Annaghmakerrig is flexible, and the craic in no short supply. 'You can eat whenever you like during the day – there's always sausages, rashers and the like in the kitchen but, every evening at seven o'clock there's a hot meal provided.

We had poker schools; we'd drink until closing time in the Black Kesh pub down the road, then back to the big house with a bottle of Black Bush. Then we'd sit up late, solving the problems of the world. It was like being a student again.'

He's fascinated by the different perspectives, the mix of people who inhabit this artists' colony, albeit for short bursts of time. 'I love the fact that you meet both established artists and young people starting out on their careers. It's a very democratic place, you pay according to what you can afford.' Again, it's the mix, the juxtaposition that appeals to him. 'You have great fun there but there's also a depth, great philosophical discussions ...' He recalls being brought up short by one young man, a Belfast poet, in a discussion about mutual schooldays. The young man in question told of how his strongest memory was of the teacher regularly shouting one phrase at the pupils, at the height of the Troubles: 'On the floor', as the bullets flew nearby. Different perspectives. Different landscapes.

At the end of the day, though, despite the craic and the camaraderie, it is for its role as an artists' sanctuary that John O'Conor really loves Annaghmakerrig. 'The seclusion,' he says, 'is so important. You can work in your room all day and no one bothers you, no one casually knocks on your door. I don't think it's a good place to come if you're still looking for the muse, however ... it's a place to come once you're on the road to creativity.'

John O'Conor delights in the history of this great house, especially the story of its mischievous dedication to the people of Ireland. 'Tyrone Guthrie left it to the State in his will when he died in 1971,' he explains, 'but there was a condition attached. The centre was to be administered jointly by the Arts Councils of both Northern Ireland and the Republic. If that had not been properly set up within ten years, the house was to revert to the ownership of Queens University in Belfast. Needless to say, it was all properly sorted out at the eleventh hour – nine years and so many months!' The centre opened in 1981.

Listening to this world-famous pianist, you get the impression of a place of great beauty and tranquillity, a place that could serve, not just for artistic inspiration, but as a retreat in the spiritual sense. He acknowledges that for some people with personal troubles, it probably does fulfil that role.

'There's a huge sense of space and freedom here. I mean, to sit in the drawing room and watch a deer walk past ... to walk by the lake, to swim in it in summer ... Everyone needs time to think and artists in particular need the security that it provides ... Annaghmakerrig really is a magical place.'

John O'Conor is an internationally acclaimed concert pianist and director of the Royal Irish Academy of Music. He studied at University College Dublin and at the Hochschule fur Musik in Vienna and has performed with orchestras such as the Czech Symphony and the Royal Philharmonic. He has presented his own musical series on both television and radio.

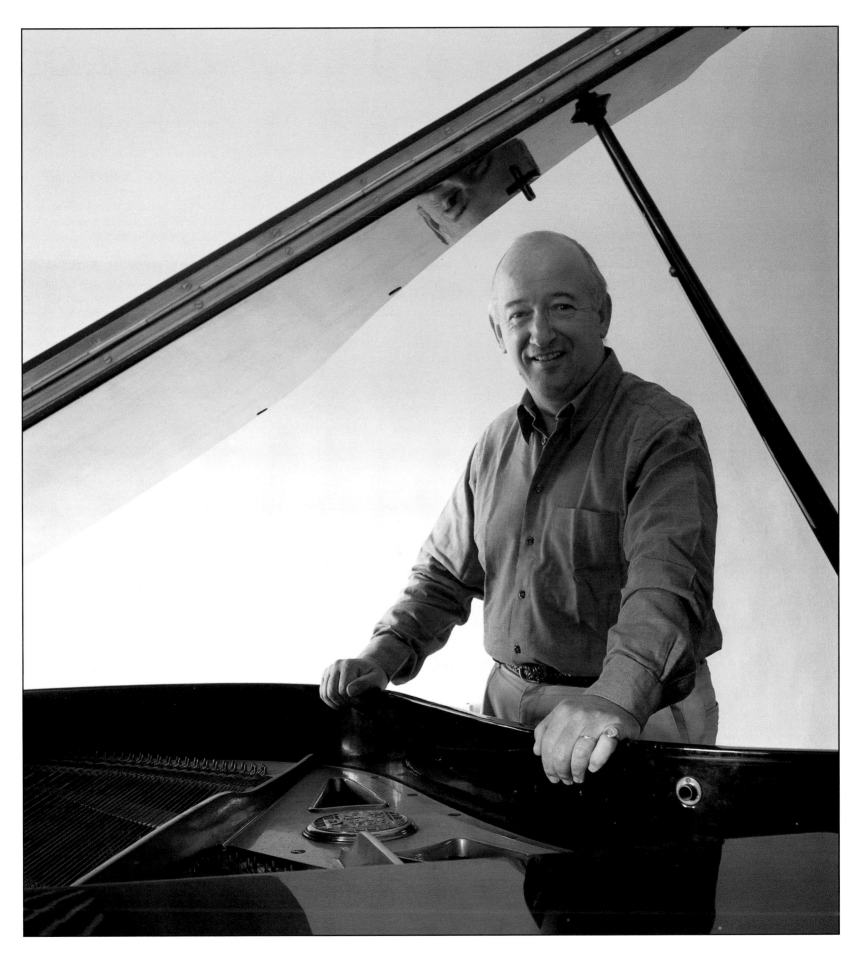

John Lonergan

Mountjoy Prison, Dublin

John Lonergan in the Women's Prison: 'you see so much humanity there' (far right); the entrance to Mountjoy (above)

John Lonergan, originally from south Tipperary, has been Governor of Mountjoy Prison in Dublin since 1984. After entering the prison service in 1968 he first served in Limerick and Portlaoise before taking up his current post. His tenure has seen a liberalising of prison life, along with greater media, and public, access to Mountjoy.

Lying on the desk in his office is an ancient tome. Leathered and weathered, it documents throughout its many pages, in a variety of scripts and inks, more than a century of death. It's the book where every demise in Mountjoy Prison is recorded for posterity – famous names, like Kevin Barry, who met their deaths by execution, unknown souls who died there from sickness, inmates murdered by fellow inmates, others who died by their own hand. It is a powerful, historic and human document. And it is that sense of humanity that best defines John Lonergan's role and purpose as Governor within these walls.

The prison consumes him, make no mistake about it. He may talk from time to time about his life beyond Mountjoy, his connection with Kilmacud hurlers and the like, but this jail is his passion and he approaches his job with something akin to missionary zeal.

Governor of Mountjoy since 1984 (and Deputy Governor for a year before that), it is, he concedes, a long time. 'It's a big chunk of my life,' he says, 'but it has been a most enriching experience. Everyday I am in touch with people who are despised by society and that has left a huge impression on me as a person. I'm constantly greatly touched by the human side of prison. It is my main objective to help humanise the system.'

Everyone greets him as he walks through the prison – 'Governor', 'Mr Lonergan', 'Sir'... And whatever about 'the boss' being acknowledged, what is particularly noticeable is that the boss acknowledges in return; everyone is addressed by their first name, family circumstances inquired into, people asked after.

It's not the building itself that draws John Lonergan in, neither the physicality nor the geography of Mountjoy. 'I don't really have a special place within the prison,' he says. 'It's the people here who make it what it is. What's important is that each person is treated as a human being. I don't judge people, that's happened to them already. I always tell the prisoners that I'm not interested in what they are in for.'

His own office is spacious, bright and airy, located at the very top of one of the buildings, only to be reached after what seems like a million-step climb (which, it has to be said, the Governor practically sprints up without pausing for breath). John Lonergan does not believe in isolating himself here, however, and quickly dismisses the idea that his office is in any way a private sanctuary – 'God, no, it's certainly not a haven,' he says laughing.

So, although he does not have a 'special' place within Mountjoy, does he feel differently about some parts of the jail? 'There's a particular softness about the Women's Prison,' he says. He's not referring to the new buildings *per se,* but to the ethos that prevails wherever the women find themselves together within the walls. 'You see so much sadness and humanity there. The women are far more vulnerable and always take their responsibilities more seriously than the men.' He explains it like this: 'The women come in here and they still worry about life outside – about the bills that have to be paid, about their children, their parents. They bring their problems and

responsibilities in here with them. With the men, the minute the prison gate slams shut behind them they can shut off and leave other people to take care of things for them. I take great inspiration from the women who come into Mountjoy.'

But what about the new, so-called state-of-the-art buildings that make up the Women's Prison?

Yes, he is proud of them and feels that if there's one thing he can say about his time here, it's that 'I did have an input into developing a better structure for the women. My last major task is to undertake the refurbishment of the male prison. It may require each block to be knocked down and rebuilt but, given my health, I hope to see that through in four to five years' time.' All told, John Lonergan has served thirty-two years in the prison service. 'I'm well past my sell-by date,' he points out.

Listening to him, you can understand why it is the ethos, and not the physicality, of Mountjoy that keeps drawing him in. Whatever about the Governor's view of himself, this is definitely a structure well past its sell-by date. An institution built one hundred and fifty years ago, with facilities for four-hundred-and-seventy prisoners, it now houses almost eight-hundred inmates. 'Instead of improving,' says John Lonergan, 'we're going the other way. This place was constructed in accordance with the principles of the great prison reformer, John Howard. It was built for single-cell occupancy and now, for over half the population in Mountjoy, the reality of life is two to a cell. We're going backwards.'

The irony of a prison called Mountjoy is that it is a place where joy is absent. The very nature of the jail dictates that it is a place filled with pain, and for John Lonergan that pain is part of his life. 'It gives me an energy,' he says, 'I try to fight it by trying to improve the system. It's a great challenge because it's so hopeless; there is so much indifference and such loneliness now because of the pace of our society. This Celtic Tiger is the focus of so much attention.'

He refers to Edmund Burke's assertion that only when we properly command our wealth will we really be rich and free. 'That hasn't happened. People are like robots, they're not in touch with the painful. Voluntarism, that essential giving of yourself, has been replaced by financial hand-outs. We're creating modern ghettoes, imprisoning our poor and our social misfits – prison is used as a vehicle to get them off the streets. At this stage I'm seeing the third generation of the same families coming through the system. All the evidence shows that the system ain't working but we're so blinkered, we can't even say that.'

Regarding the sense of history that permeates Mountjoy, John Lonergan speaks about those individuals, like executed inmate Kevin Barry, who fought and gave their lives for what they believed in. 'I don't believe that any cause is worth giving your life for,' he says.

The irony is lost on him. There are causes, and then there are other causes. Some you die for. But for others you stay alive and keep battling, way past your sell-by date, right to the bitter end.

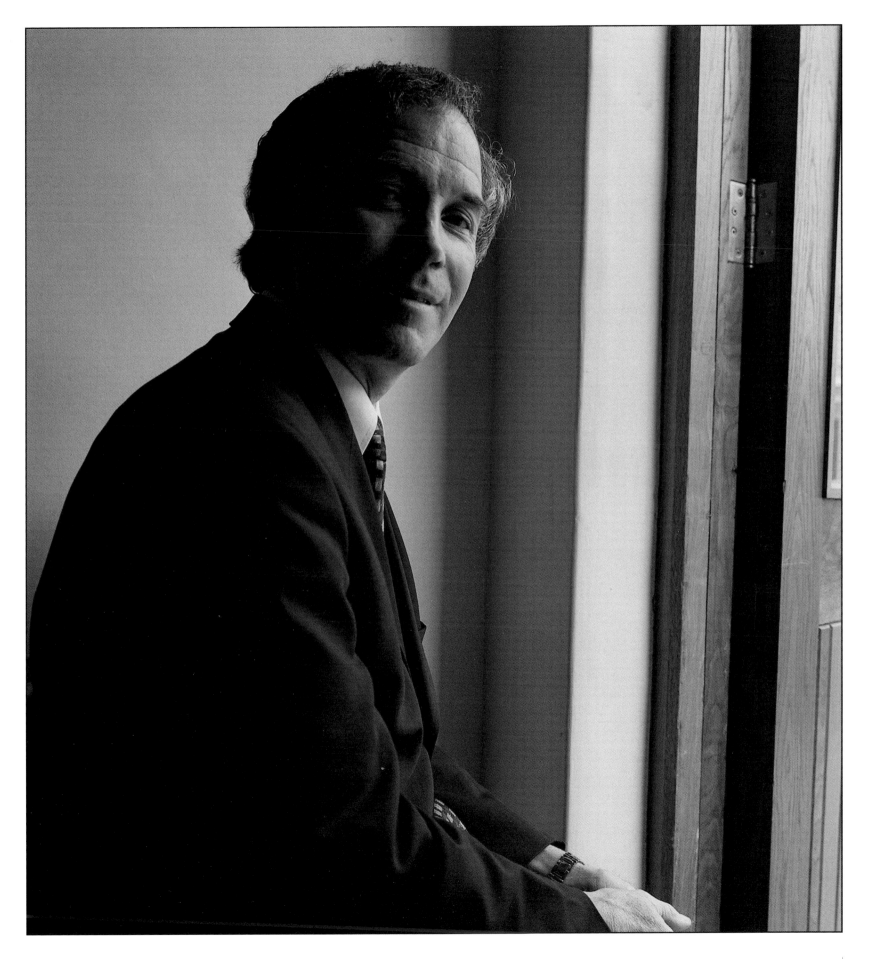

Acknowledgements

We would like to thank all thirty-five people
who agreed to take part in this book and
who gave so generously, of themselves, and
of their time, to facilitate us.

Thanks also to publisher Edwin Higel for his
enthusiasm and encouragement for the
project right from its embryonic stage and to
our editor, Ciara Considine, for her
professional guidance and her
endless patience.

And to Deirdre McQuillan, who read the first
drafts, our grateful appreciation for her
valuable suggestions, keen editorial eye, and,
as always, her encouragement, support and
friendship. Also to Stephen Ryan, for his
professional perspective and, as ever, for his
unfailing sense of humour.

Thanks are also due to Joe Coyle of *The
Sunday Tribune,* Margaret O'Reilly of the
Northern Ireland Tourist Board, Greg Lokko
of Colour Repro and the team at Film Bank.

We would also like to gratefully acknowledge
EBS Building Society for their financial
support towards this project.

And finally, to our families – to our respective
sons, Demian and Nicholas, to whom this
book is dedicated, to Roslyn's mother and
father, Marion and Jim Leighton, to her sister
Pauline, and to Gerry's brother Sean – many
thanks for all their encouragement and for
putting up with our frenzied
lives for the past year.

Photograph overleaf:
St Stephen's Green, Dublin

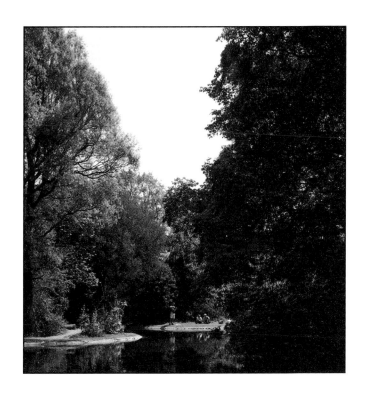